RICKMANSWORTH, CROXLEY GREEN & CHORLEYWOOD

THROUGH TIME

John Cooper

AMBERLEY PUBLISHING

Also by John Cooper

A Harpenden Childhood Remembered: Growing up in the 1940s & '50s
Making Ends Meet: A Working Life Remembered
A Postcard From Harpenden: A Nostalgic Glimpse of the Village Then and Now
Watford Through Time
A Postcard From Watford
Harpenden Through Time

To my darling wife Bet and all the family

First published 2014

Amberley Publishing
The Hill, Stroud, Gloucestershire, GL5 4EP
www.amberley-books.com

Copyright © John Cooper, 2014

The right of John Cooper to be identified as the
Author of this work has been asserted in accordance with
the Copyrights, Designs and Patents Act 1988.

ISBN 978 1 4456 4050 1 (print)
ISBN 978 1 4456 4083 9 (ebook)

British Library Cataloguing in Publication Data.
A catalogue record for this book is available from the
British Library.

Typesetting by Amberley Publishing.
Printed in Great Britain.

Introduction

During the early part of the twentieth century, countless images of Rickmansworth, Croxley Green and Chorleywood were captured on camera by dedicated photographers such as A. Darrah and T. J. Price. The numerous pictures taken provided an everlasting legacy of the three areas' development, recording for posterity not only copious street scenes and buildings, many of which are now listed and preserved, but also events as diverse as traffic accidents and visiting royalty.

One of the important by-products of all these images was the picture postcard, a popular and fast means of communication in Edwardian times, where a message sent to a loved one in the morning was very often guaranteed to be received the same day.

Using a selection of these old postcards, many of which have been stored in dusty attics, untouched for generations, coupled with modern-day photographs, this nostalgic glimpse into the fascinating scenes of yesteryear takes the reader initially on a journey around Rickmansworth, visiting interesting places such as the historic Basing House, once the home of Quaker William Penn, the founder of Pennsylvania. Today, part of the old building houses the superb museum where permanent displays, exhibits and photographs reflect the rich history of the town.

Wandering down Church Street, we pass the splendid parish church of St Mary the Virgin before arriving at the site of Rickmansworth's first railway, the Watford and Rickmansworth, which was opened in 1862 by Lord Ebury. Arguably, the jewels in Rickmansworth's crown are the three lakes of Batchworth, Bury and Stocker's (the latter now a beautiful nature reserve), and the lovely vista of the canal and rivers that wend their way around the town.

Travelling the short distance up nearby Scots Hill is the pretty village of Croxley Green, where the long verdant expanse of the green itself extends from All Saints church on Watford Road to Croxley House, situated at the northern end near Baldwins Lane, once the home of Thomas Villiers, the 1st Earl of Clarendon. Each year, throngs of people gather on the green where the popular midsummer Revels are held and where an action-packed afternoon is guaranteed for all. The Revels, which commenced in 1920, generated the start of an annual tradition that thrives and continues to this day. We witness the Great Barn, a magnificent Grade II-listed threshing barn, situated near Croxleyhall Wood, dating back to the late fourteenth century, one of the oldest of its type in Hertfordshire.

Motoring on to the lovely village of Chorleywood, we pass Tollgate House, where George Alexander, the renowned actor, theatre producer and manager, lived at the turn of the nineteenth century, producing some of Oscar Wilde's plays, including *Lady Windermere's Fan*. We pause for a while at Younger's Retreat, a charming dwelling that was once a farmhouse and dates back to the pre-Tudor period before arriving at our final destination in Chorleywood, the historic King John's Farm, a splendid old house that was built in the late Middle Ages. It was here that the marriage took place between William Penn and Gulielma Springett, and where, in the isolation of Chorleywood, the Quaker movement could flourish unimpeded.

Despite the ongoing transformation that is gradually taking place with each passing year, we owe an enormous debt of gratitude to those early photographers. With their bulky cameras and tripods, primitive when compared to today's sophisticated equipment, they braved the elements throughout the four seasons to provide us with a lasting legacy of Rickmansworth, Croxley Green and Chorleywood's heritage, as illustrated on the following pages by the use of the simple postcard.

John Cooper

Acknowledgements

I am extremely grateful to the following for their kind assistance, for their helpful and constructive advice and comments, and for giving me the benefit of their specialised and local history knowledge, all greatly appreciated: Laurie Akehurst, London Transport Museum; Lyndon Bedwell, Classic Wedding Cars, Uxbridge; Rod Branford; Shaun Burgin, Chorleywood Library; Bob Clarke, Watford Borough Council; Carolynne Cotton, Archives and Museum Manager, Uxbridge Civic Centre; David Crozier, *Watford Observer*; Brian Donnelly, Chairman, Rickmansworth Town Football Club; Olive Entwhistle; Deborah Follett, Croxley Green Library; Ian Foster; Barry Grant, Croxley Revels Organiser; David Harding; John Harrington; Don Hide, Affinity Water Limited; Barbara Holden; Adrienne Jacques; Ben Lawless, Three Rivers District Council; Vanessa Lacey and the staff of Watford Central Library; Billy Lees, Estates Manager, Royal Masonic School for Girls; Sean McGuigan, Legal Services, Affinity Water Limited; Geoff Marshall-Taylor, Church Warden, Christ Church, Chorleywood; Andy Matthews, Rickmansworth station; Cllr Les Mead, Chairman, Three Rivers District Council; Syd Millward; David Montague, Festival Director and Chairman, Rickmansworth Waterways Trust; Barbara Owen, MBE, Chairman, Three Rivers Museum of Local History; Margaret Owen, Hon. Curator and Exhibition Designer, Three Rivers Museum of Local History; Carol Palmer, Rickmansworth Library; Roger Puddephatt; Peter Rodwell, Secretary, Chorleywood Golf Club; Alan Russell, Bury Lake Young Mariners; St Joan of Arc Catholic School; Paul Samson-Timms; Geoff Saul; Mark Saxon, Rickmansworth Waterways Trust; Ann Shaw, OBE, Leader, Three Rivers District Council; Peter Waters, MA, FRSA, Our Lady Help of Christians Catholic church; Ian Watson, Chairman, Friends of Stocker's Lake; and Mary Weatherilt, Rickmansworth and District Horticultural Society.

Special thanks are extended to my wife, Betty, for her constant support, encouragement and invaluable input; to my son Mark for his continuous IT support; and to my publishers, Amberley Publishing, for their kind assistance in producing this publication.

Every endeavour has been made to contact all copyright holders, and any errors that have occurred are inadvertent. Anyone who has not been contacted is invited to write to the publishers, so that a full acknowledgement may be made in any subsequent edition of this book.

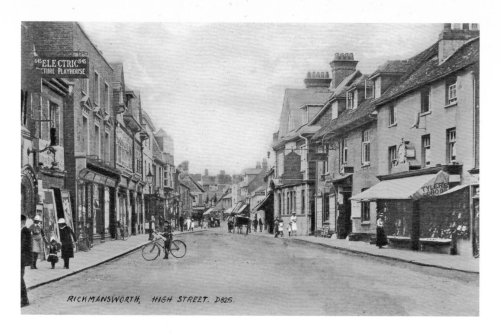

RICKMANSWORTH, HIGH STREET. D825.

High Street, Rickmansworth

This picturesque thoroughfare shows the old town hall on the extreme left, which was converted into the town's first cinema, the Electric Picture Playhouse, opening in 1912 with a seating capacity of 300. The silent films of the day were often interspersed with variety acts. An early proprietor was R. Barnett, but in later years the cinema was run as the Electric Palace by A. Smith and his French wife. This remained the town's only cinema until 1927, when the Picture House, run by a group of local businessmen, opened on part of the Brewery Estate, then owned by W. H. Walker & Brothers Ltd, at the east end of the town. Perhaps one of the best known buildings in the High Street was the Swan Hotel, seen on the right, once a posting house on the road to Aylesbury and Bicester. It was demolished in 1964, with the site now occupied by the post office, a shoe shop and a dry cleaner.

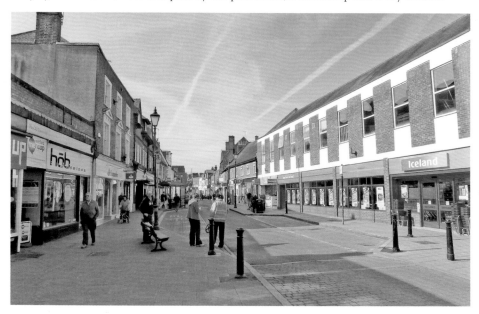

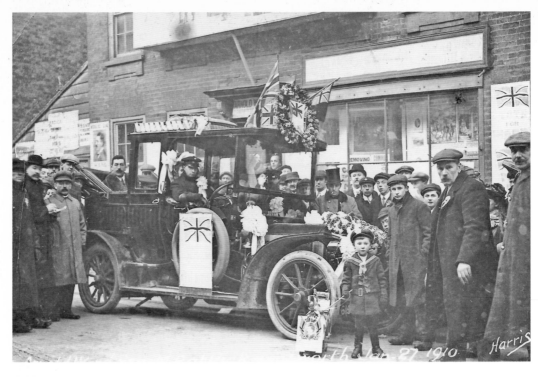

Arnold Ward MP

The newly elected, Eton educated Member of Parliament for Watford, Arnold Ward, is seen making a short visit to Rickmansworth on Thursday 27 January 1910. Pausing for a while in front of the Swan Hotel, accompanied by an inquisitive crowd of onlookers keen to get into the picture, the MP would no doubt adjourn to the adjoining hostelry for some post 'photo shoot' imbibing before motoring to his next port of call. Arnold Ward remained Watford's MP until the 1918 General Election, when the Conservative Party in Watford decided to select another candidate for the constituency. He died on 1 January 1950, aged seventy-four.

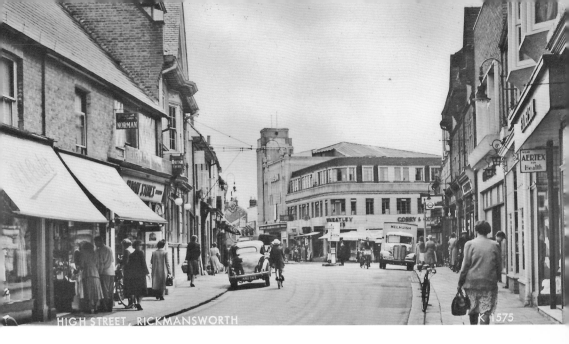

High Street Looking East

With the large building of the Odeon cinema dominating the corner of Church Street, this photograph postcard of the High Street can be dated to the austere, post-war years of the early 1950s. The exclusive gown shop of Miss A. M. Coster at No. 70 (*pictured on the left behind the bicycle*) may well have seen an increase in business, with clothes being derationed in 1949. Advertising 'Aertex' on the opposite side of the road are the premises of Ernest H. Nelson, a draper, milliner and school uniform outfitter. The Odeon, which opened its doors on 29 January 1936 with the inaugural film *On Wings of Song* starring Grace Moore, was never as popular as the two Watford Odeons, which tended to attract keen cinemagoers from further afield. With many Odeons and Gaumonts losing money, a decision was made by the Rank Organisation to close fifty-nine of their theatres in late 1956, including Rickmansworth, which closed after the Christmas holidays on Saturday 5 January 1957 with the showing of *The Mountain* with Spencer Tracey. The closure was just a few weeks short of the cinema's twenty-first anniversary.

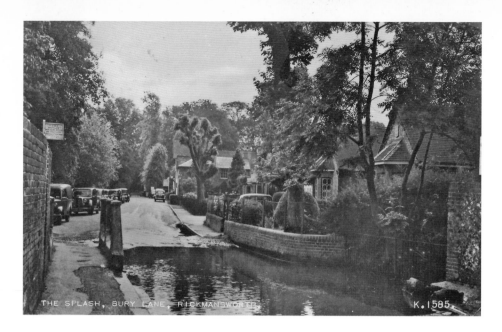

THE SPLASH, BURY LANE, RICKMANSWORTH K.1585.

The Watersplash, Bury Lane

Once the private roadway from the High Street to The Bury, Rickmansworth's manor house, Bury Lane was given public access to the town in 1799 by Henry Fotherley-Whitfield, on condition that the footbridge at the side of the ford, where the stream known as the Town Ditch ran, was maintained. Over the years, countless youngsters had enjoyed paddling or fishing for tiddlers, but in the harsh winter of 1963, when the ford froze and the lane had to be closed, a decision was made by the council to culvert the 'Splash'. The distinctive front façade of the Beresford Almshouses can be seen on the right.

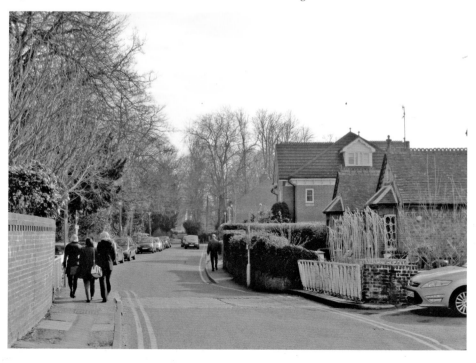

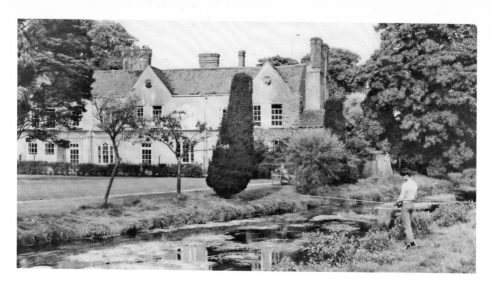

The Bury

With a chequered history of occupants, the lovely manor house of The Bury was purchased by Thomas Fotherley in 1632; however, due to the property having been leased to Sir Gilbert Wakering in 1610 for a sixty-year period, he was unable to live there. The estate was then left to John Fotherley, Thomas's younger son, but when he died in 1702, the manor then passed to his wife, Dorothy, as there was no surviving issue. Dorothy continued to live at The Bury until her death in 1709, when the house and land were left to her nephew, Temple Whitfield, and his brother Henry. On Temple's demise in 1732, and with the family name now Fotherley-Whitfield, everything was bequeathed to his nephew, Henry. It was Henry's son, also named Henry, who built the palatial Rickmansworth Park House in 1786. During the Second World War, The Bury was used as the local Civil Defence headquarters, and following the cessation of hostilities, the building was taken over by Hertfordshire County Health Authority as a health centre. Today, The Bury has now been tastefully converted into 'seven houses linked together'.

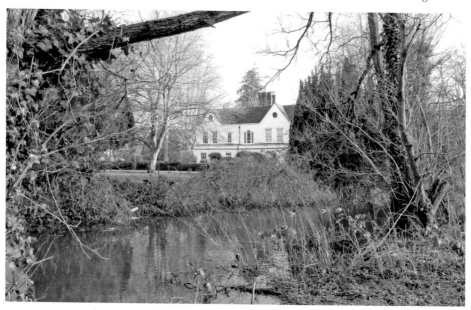

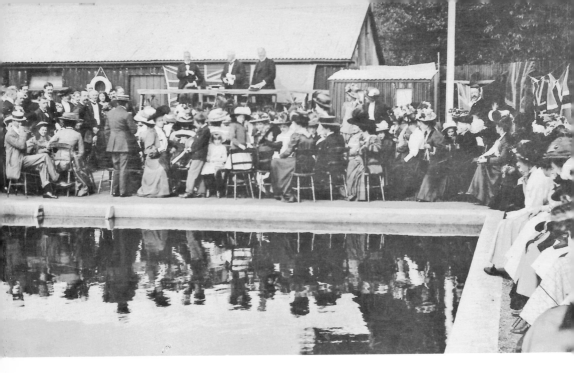

The Swimming Baths

An excellent attendance comprising a number of civic dignitaries and a crowd of excited spectators gathered to hear Lord Ebury officially open the new Rickmansworth open-air swimming baths on Wednesday 9 June 1909. Although it was a popular venue, it was constantly freezing cold as no heating was ever installed. In later years, the Urban District Council took over the running of the pool until a serious leak developed, which was unable to be repaired, resulting in the pool's closure. The land was subsequently developed for residential purposes in what is now Goral Mead, just off Ebury Road, with the stream called the Town Ditch running alongside.

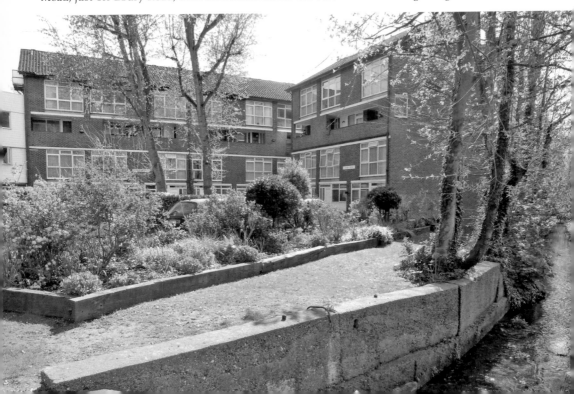

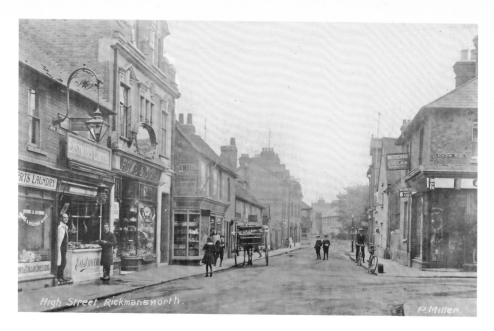

High Street, Rickmansworth.

P. Miller

High Street – Junction with Station Road

This snapshot, taken in the early 1900s, depicts a quiet part of the High Street at the junction with Station Road, and although the 2014 image appears at first glance to be similarly devoid of vehicles, this was only a brief lull in the normally busy flow of through traffic. Some of the retailers pictured at this end of the town are the Royal Herts Laundry, whose shop window proclaimed they were 'Shirt & Collar Dressers' and that 'Dying and Cleaning' was also undertaken; Eastmans Limited, a high-class butcher's; the baker's shop of C. H. Howe & Son; and the tobacconist's premises of James Lambert Bell, who also offered a hairdressing service. On the corner of Station Road can be seen George Bassill's shop, where motors and cycles were repaired.

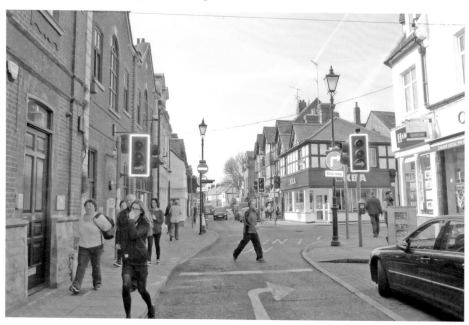

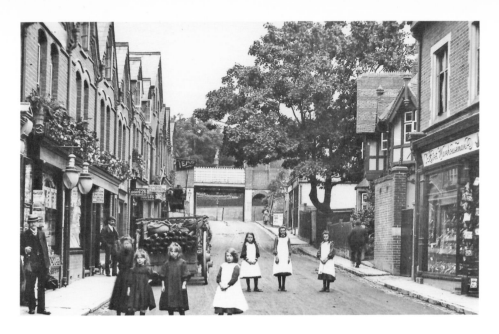

Station Road

The arrival of the photographer has certainly attracted the attention of this group of young girls at play in Station Road, although the picture does appear to be carefully posed. On the right is the well-established business of John Richie Ibbotson, a clothier and draper, who also sold a variety of workwear, including carpenters' aprons, overalls and boots. Other shops in Station Road, once known as Keepers Hill after the bailiff to the Rickmansworth Park Estate, include a florist's, a dyer and cleaner, and a boot and shoe repairer. The bridge in the background carries the Metropolitan Railway, which arrived in Rickmansworth in 1887.

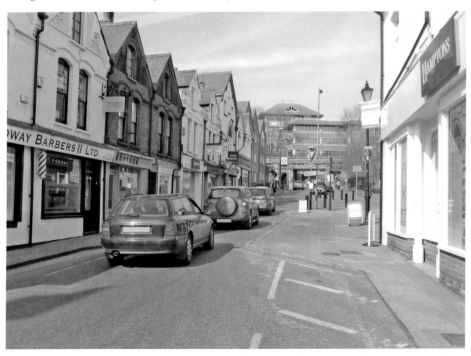

Swannell & Sly and H. Barton

Above right is an advertisement for the long-established firm of estate agents, auctioneers and valuers, Messrs Swannell & Sly. The image below right is the 1933 receipted bill from Harry Barton, corn, meal and seed merchant, for goods supplied to Miss Grahame-Weall.

☞ Established over a Quarter of a Century.

MESSRS.

Swannell & Sly

Auctioneers and Valuers,
. . Estate Agents, . .
Architects and Surveyors.

Chief Offices:

HIGH STREET, RICKMANSWORTH.
1a, MAXWELL ROAD, NORTHWOOD.

Branch Offices:

PINNER, CHORLEYWOOD, AMERSHAM,
WENDOVER.

A Selection of the principal Residences,
FOR SALE AND TO LET,
may be obtained on application.

Telephones { 6 RICKMANSWORTH
19 NORTHWOOD

CORONATION OF
HER MAJESTY
QUEEN ELIZABETH II

2nd JUNE 1953

Elizabeth R
1953

PROGRAMME OF LOCAL EVENTS

Published and Distributed by authority of
the Rickmansworth Urban District Council

RICKMANSWORTH URBAN DISTRICT

Programme of Events

RICKMANSWORTH TOWN

WEDNESDAY, 27th MAY

Organised by Rickmansworth Darby and Joan Club, W.V.S. Office, Council Offices, Rickmansworth.

Coach Outing to London to View Coronation Decorations and flood-lighting with tea and presentation of souvenir to each member.

Picking up places at THE WHIP AND COLLAR *P.H., Mill End at* **1.20 p.m.**, CROXLEY MET STATION *at* **1.20 p.m.** *and the* COUNCIL OFFICES *at* **1.30 p.m.**

(NOTE:—*For Darby and Joan Club Members only.*)

TUESDAY, 2nd JUNE—CORONATION DAY

Organised by G. Jones & Son (Rickmansworth) Limited and the Vicar of Rickmansworth, 54 High Street, Rickmansworth.

10 a.m. Television Showing of Coronation Procession and Service. THE EBURY HALL, RICKMANSWORTH.
(NOTE:—*For Darby and Joan Club Members.*)

Organised by Rickmansworth Branch British Legion, Captain A. Palmer, D.S.O., British Legion H.Q. Ebury Road, Rickmansworth.

5 to 7.30 p.m. Fancy Dress Procession, two bands, uniformed organisations, tableaux, etc. (Entry forms from British Legion H.Q.)

Assembly point at BATCHWORTH—*Route via* CHURCH STREET, HIGH STREET, RECTORY ROAD, STATION ROAD, HIGH STREET *and* PARK ROAD *to* SCOTSBRIDGE PLAYING FIELD.

Organised by Rickmansworth Townswomen's Guild, Secretary, Mrs. E. Gravestock, 11 The Cloisters, Rickmansworth.

8 to 10 p.m. Pageant of National History—Elizabeth I to Elizabeth II. Programmes 1s. each. Free admission to Bury Gardens. THE BURY GARDENS, RICKMANSWORTH.

8.55 p.m. THE QUEEN'S SPEECH will be broadcast from the Council Offices and the Bury Gardens.

Organised by Rickmansworth and District Residents' Association, Secretary, J. B. Smeaton, Esq., The Bury Restaurant, Bury Lane, Rickmansworth, and the Scout Groups of the Urban District.

10 to 11 p.m. Firework Display and Bonfire. THE BURY GARDENS, RICKMANSWORTH.

5

Coronation of H.M. Queen Elizabeth II
Tuesday 2 June 1953 was Coronation Day, and despite the miserable weather, Rickmansworth had organised a feast of entertainment to appeal to everyone from the young to the not-so-young. A special treat for local Darby and Joan Club members was a television showing of the Coronation procession and service in the Ebury Hall, arranged by G. Jones & Son (Rickmansworth) Limited and the vicar of Rickmansworth. At 5 o'clock, a grand fancy dress parade assembled at Batchworth, complete with a stunning array of tableaux and decorated floats, accompanied by two marching bands and a large contingent of the local uniformed organisations. To the cheers and applause of the crowds lining the route, the procession snaked its way to Scotsbridge Playing Field via Church Street, High Street, Rectory Road, Station Road, High Street and Park Road. This was followed by a glittering pageant of national history from the first Elizabeth to Elizabeth II, organised by the local Townswomen's Guild in The Bury grounds. The superb finale to this special occasion was a fantastic display of fireworks that seemed to go on forever, a fitting end to a wonderful day that for a while had brought some much needed colour and excitement to that drab, austere period of post-war Britain.

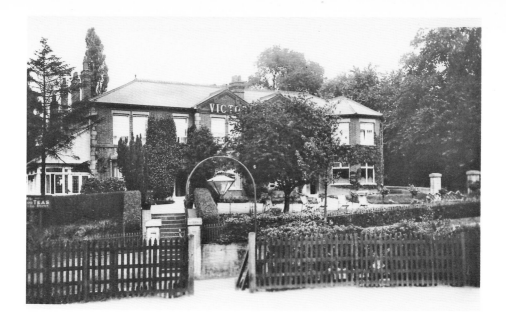

The Victoria Hotel

Originally owned by the Sedgwick family and situated opposite Rickmansworth railway station, the Victoria Hotel opened for business in 1888. Described as a 'first-class family and residential hotel', the Victoria could accommodate up to 300 people in its luxurious and spacious ballroom, which was available for parties and dances. The writer of this postcard, which was dated 2 January 1913, wished the recipient, a Mrs Osborne in Dunfermline, the compliments of the season and went on to say 'we have had a most enjoyable time here at Aunt Agnes and Uncle Samuel's Silver Wedding. Leaving tonight for home.' A lovely venue to celebrate such a memorable milestone. The bottom photograph shows the Victoria, now the popular Long Island Hotel, Bar and Restaurant.

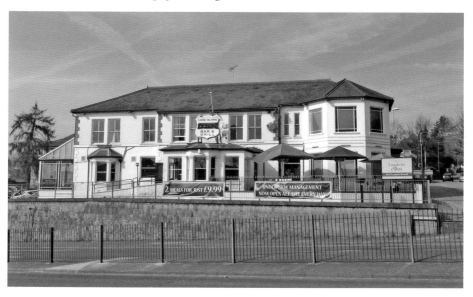

METRO-LAND

PRICE TWO-PENCE

Metroland
Two lovely advertisements enticing the visitor to the beautiful area of Metroland, those districts served by the Metropolitan Railway where specially reduced fares were on offer to rambling parties.

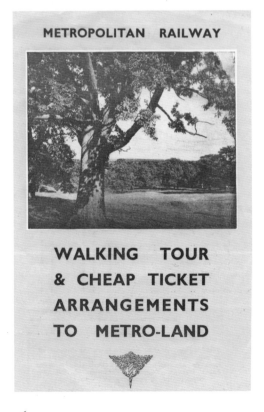

METROPOLITAN RAILWAY

WALKING TOUR & CHEAP TICKET ARRANGEMENTS TO METRO-LAND

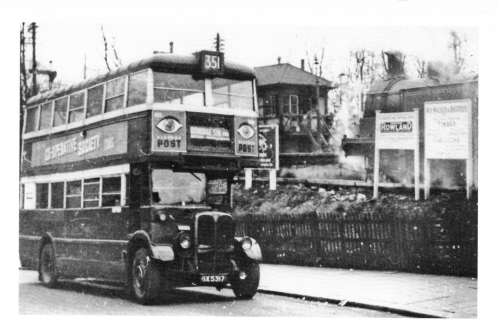

Station Approach, Rickmansworth

Seen above is double-decker bus ST1073 outside Rickmansworth station. The bus was delivered new to London General Country Services and allocated to Watford High Street Garage in August 1932. The body design was called 'Bluebird' after a batch of 'Bluebird' LTs. Route 351 was introduced on 12 November 1947, to take over the Uxbridge to St Albans section of Route 321, and included many short workings between Maple Cross, Rickmansworth, Croxley and North Watford/Garston. ST1073 was taken out of stock on 19 December 1950. While the Metropolitan Railway steam locomotive in the top picture is long gone, the siding still exists. The signal box in the background was demolished around 1954. The building, as depicted in the 2014 image, was constructed initially for train crew accommodation, but is now used by the technical officers who repair the signals and points.

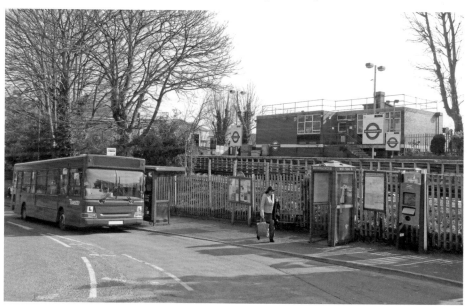

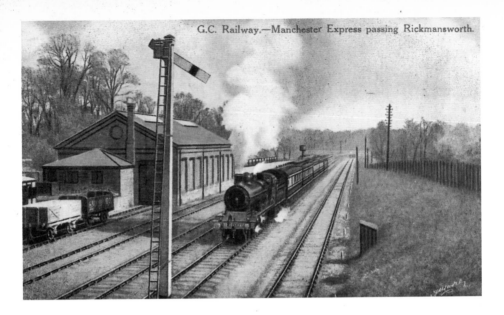

Manchester Express

The Great Central Railway London extension was opened in 1899. A Marylebone to Manchester express approaching Rickmansworth, goods shed and yard on the left, around 1905. Following the opening of a station at Harrow-on-the-Hill on 2 August 1880, the rapidly expanding Metropolitan line reached Rickmansworth on 1 September 1887, and Aylesbury on 1 September 1892. With the line becoming electrified as far as Rickmansworth in 1925, the station became a changeover point where steam locomotives replaced the electric locomotives for the remainder of the journey to Aylesbury. The uncoupling and coupling operation was believed to have taken an impressive four minutes. The process was reversed for trains returning to London. It wasn't until 1961 that the line was fully electrified, with the last steam train running in the September of that year. The image below shows a section of a Philips map (c. 1900–05), issued as a postcard for promoting the Metropolitan Railway and its surroundings in the Chilterns.

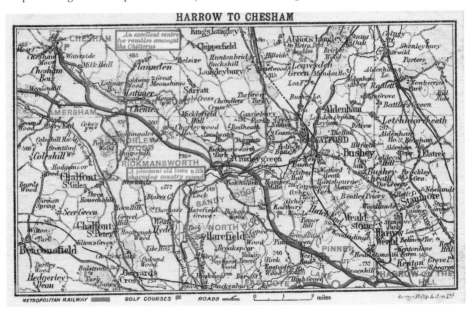

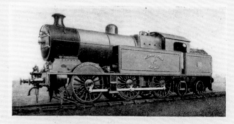

ONE OF THE NEW 73-TON LOCOMOTIVES.

Yuletide Bonhomie

A parcel, together with a card from R. H. Selbie, the general manager, was sent to all Metropolitan Railway Company employees serving their country in the armed forces during the First World War. The package, sent at Christmas 1916, no doubt contained some much needed necessities, with possibly a small luxury or two such as cigarettes and tobacco. The card's message read, 'The accompanying parcel is sent with the best wishes of the Directors, Officers and Staff of the Metropolitan Railway Company. In whatever part of the world you are serving your Country at this time, and in whatever capacity, be assured that you are often in the thoughts of those who are carrying on the work of the Railway in your absence and who, especially at this Christmas-time, wish you God-speed in the splendid cause in which you are engaged.'

CHRISTMAS
1916

THE accompanying parcel is sent with the best wishes of the Directors, Officers and Staff of the Metropolitan Railway Company. In whatever part of the world you are serving your Country at this time, and in whatever capacity, be assured that you are often in the thoughts of those who are carrying on the work of the Railway in your absence and who, especially at this Christmas-time, wish you God-speed in the splendid cause in which you are engaged.

R. H. SELBIE,

General Manager.

BAKER STREET STATION,
LONDON, N.W.

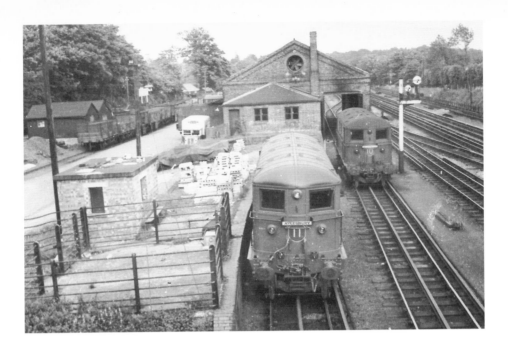

Awaiting the Changeover

Two electric locomotives (known as 'growlers'), No. 10 *W. E. Gladstone* and No. 11 *George Romney*, waiting in bay sidings for the arrival of trains travelling from Aylesbury under steam traction. Steam locomotives would then be uncoupled and the train coupled up to the electric locomotives for the onward journey to Baker Street. Behind the locomotives in this photograph, taken on 23 May 1953, is the goods shed, while in the yard on the left can be seen some coal trucks, pallets, a British Railways van and a cattle dock/horse loading stage in the foreground. A Waitrose supermarket now occupies the site of the old sidings and goods yard.

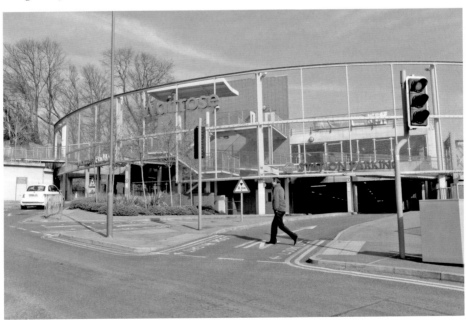

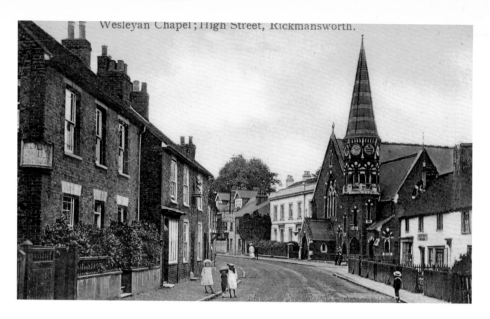

Wesleyan Chapel, High Street

This postcard, dated 19 October 1907, shows the Wesleyan chapel on the corner of Wharf Lane in the High Street. Constructed at a cost of £2,500, the chapel was consecrated in 1866 and was in constant use until the early 1980s, when the plot was sold. Following demolition in 1984, the site is now occupied by office accommodation, with a car park replacing the cottages on the corner of Talbot Road. On the other side of the High Street at No. 22 is the lovely old public house, the Coach and Horses. This dates back to the early 1700s, or possibly earlier, and was originally purchased by Samuel Salter, a brewer, in 1741. An interesting snippet from those far-off days was that in his will, Samuel's grandson, also named Samuel, ordered that a free cask of ale be left outside the brewery a short distance away for travellers and passers-by. The practice was so popular that it attracted large crowds eagerly awaiting the arrival of the daily 36-gallon barrel of beer. However, in 1857, the tradition was stopped because fights would break out when the cask was found to be empty in less than an hour!

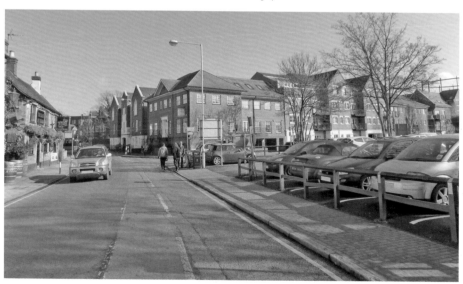

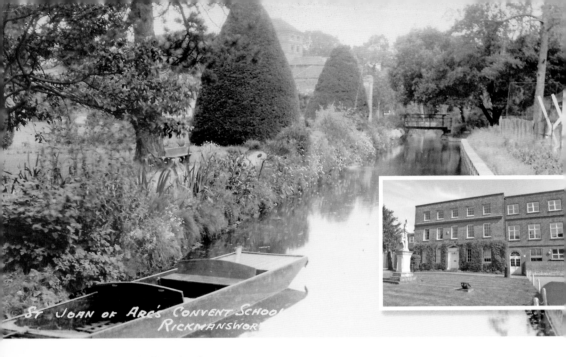

St JOAN OF ARC'S CONVENT SCHOOL
RICKMANSWORTH

St Joan of Arc Catholic School

The tranquil scene above shows the River Chess and part of the lovely grounds of the St Joan of Arc Catholic School, founded in 1904 by the Filles de Jesus (Daughters of Jesus). The Grade II-listed main house of the school was previously The Elms, once the home of the renowned Victorian novelist George Eliot, the pen name of Mary Ann Evans (1819–80). It was during her residence of the house that she wrote her book, *Daniel Deronda*, published in 1876. Today, this Georgian building, with the imposing statue of St Joan designed by former pupil Joan Jackson in 1939 (*inset*), houses the reception area, staff room and administrative offices. The photograph below depicts an early view of the school building. St Joan of Arc was awarded grammar school status in 1951, remaining so until the transition to comprehensive co-education in 1975. The school celebrated its centenary in 2004.

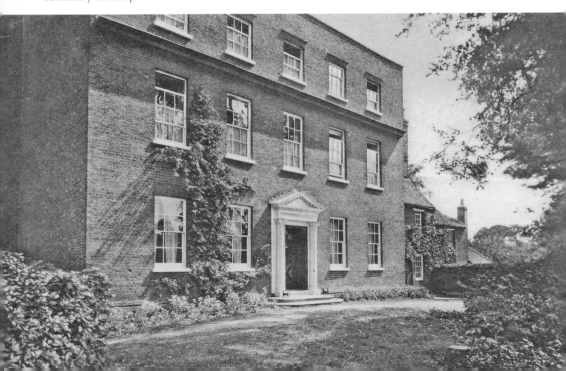

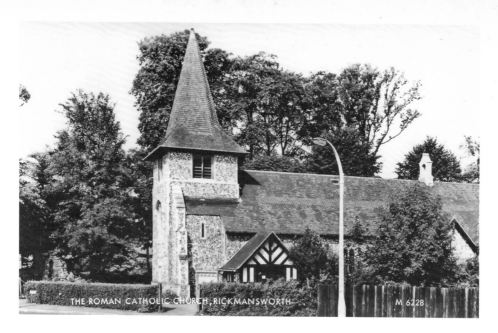

THE ROMAN CATHOLIC CHURCH, RICKMANSWORTH M 6228

The Roman Catholic Church (1)

The present Church of Our Lady Help of Christians was opened on Tuesday 26 October 1909 by Archbishop Bourne on a 2-acre site belonging to the Salter Brewery Company in Park Road. Previously, a corrugated iron chapel built by Father Hardy in the High Street had been used, but following the handover to the Augustinians of the Assumption around 1904, a more permanent home was sought. With the land purchase came some existing buildings, which were subsequently converted into St Augustine's priory and hall, the church being built adjoining the latter. The church was eventually consecrated by His Eminence Cardinal Hume, the Archbishop of Westminster, on 8 April 1981, seventy-one years after it was opened. This extensive delay was due to the expense involved.

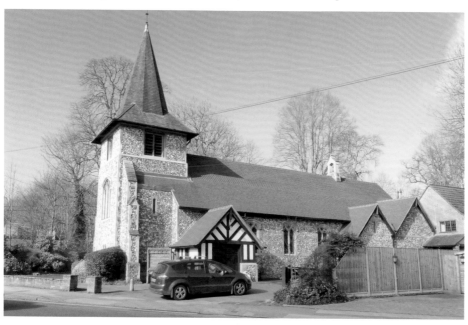

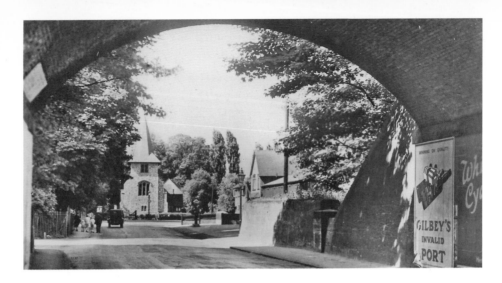

The Roman Catholic Church (2)

A late 1920s/early 1930s view above of the Catholic church of Our Lady Help of Christians seen through the arch of the High Street Metropolitan Railway bridge. An amusing little anecdote is recalled by Peter Waters in his *History of the Parish*; in 1898, Father Hardy, who had established a Catholic Mission in Rickmansworth around two years earlier, was offering Masses every Sunday to other local missions, as well as Rickmansworth. His mode of transport was a trap pulled by a rather unreliable donkey, which at one point refused to budge. Father Hardy, already late for Mass, eventually coaxed the awkward beast to move, but was reported to the RSPCA by a lady bystander, who allegedly claimed that a whip was being cruelly used. Later appearing before the Watford magistrates, the case was dismissed after Father Hardy stated that he had not used a whip, only his pocket handkerchief. Coincidentally, not long afterwards, the donkey died and the Father was reduced to walking for a short while, a daunting task indeed. A young family is seen on the left of the picture, out for a leisurely stroll on a lovely summer's day, while the hoarding under the bridge advertising Gilbey's Port implies that the fortified wine would appear to be beneficial for invalids.

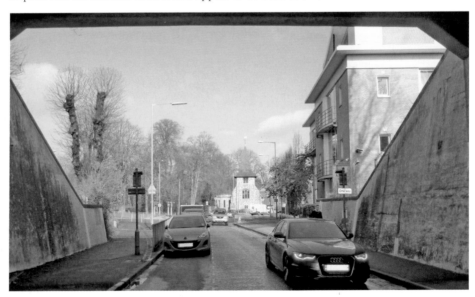

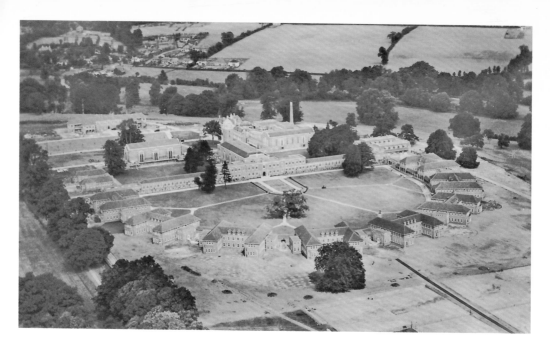

The Royal Masonic School for Girls

Once owned by the Lord of the Manor of Rickmansworth, Henry Fotherley-Whitfield, the beautiful Rickmansworth Park, together with the palatial house (*pictured below*), was sold in 1926 by Viscountess Barrington, the then occupier of the estate, to the Royal Masonic Institution for Girls. It was planned that a new school would be built to accommodate the relocation of the pupils from their existing premises in Clapham. The school was formally opened by HM Queen Mary on Wednesday 27 June 1934. The postcard above shows an early aerial photograph of the grounds and school buildings.

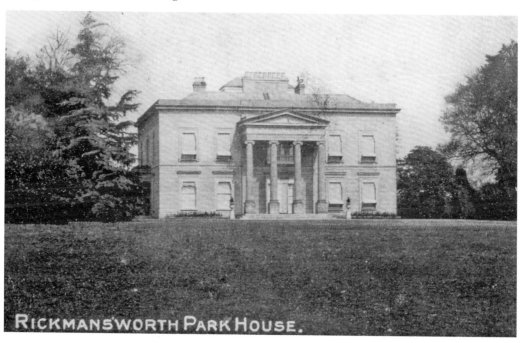

RICKMANSWORTH PARK HOUSE.

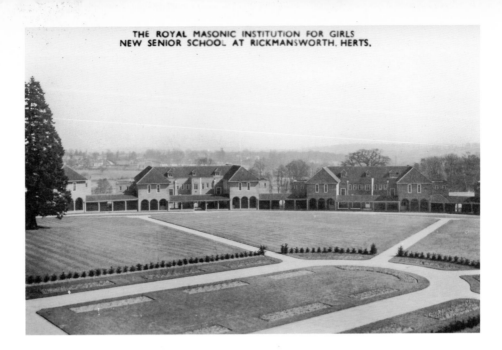

THE ROYAL MASONIC INSTITUTION FOR GIRLS
NEW SENIOR SCHOOL AT RICKMANSWORTH. HERTS.

The Garth – Royal Masonic School

This elevated view shows the enclosed space of the Garth with some of the school houses, also known as Garth Houses, in the background of this lovely site, which were all connected by a covered way, much along the lines of a medieval monastery cloister. The picture would have been taken in 1934, probably just prior to the official opening, and shows a large grassed area in the foreground with several rose beds. This was where the library (now the resources centre) was later constructed.

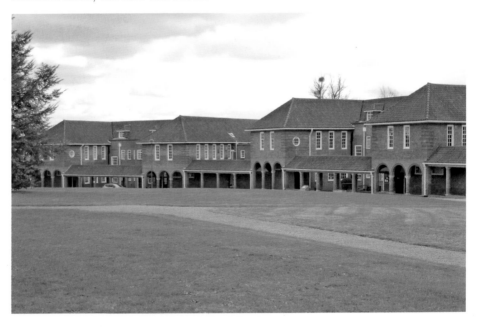

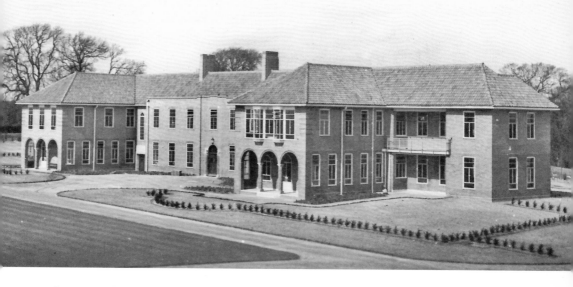

The Sanatorium and Swimming Bath – Royal Masonic School

With the risk of tuberculosis and other infectious illnesses in those early days, it was important for the building design of the new sanatorium to have a southerly aspect with large windows, as it was felt that the benefits of fresh air and sunlight were deemed to aid recovery. Some individual rooms were incorporated where segregation was necessary to facilitate separate treatment. The sanatorium boasted a fully equipped and up-to-date operating theatre, a surgery and dispensary, and a dental surgery, and could accommodate up to fifty patients. There was also a separate kitchen area. The indoor swimming pool can be seen below, complete with diving boards and an array of changing cubicles down each side of the pool. Today, the sanatorium is now the junior school, while the swimming pool, now modernised, no longer has diving boards due to health and safety.

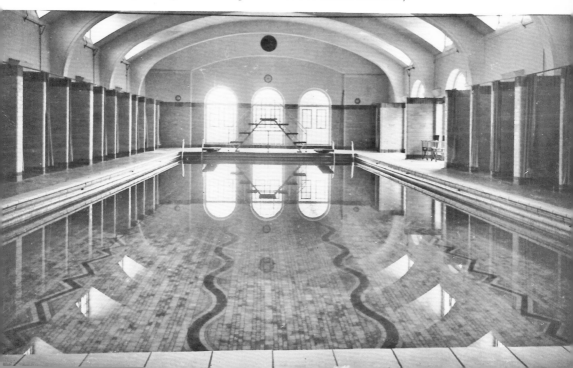

Reside at
RICKMANSWORTH
FAR FROM THE MADDING CROWD
Yet within 26 minutes run by Metropolitan Railway from Baker Street
**MAKE THIS THE END OF YOUR QUEST
AND ENSURE PERFECT REST**
ENQUIRY : DEMONSTRATION : SATISFACTION

Detached and Semi-Detached Residences
are now being erected in
Mount View, Cedar's Estate, Rickmansworth

DISTINCTIVE DESIGNS

Two Reception ; 3 or 4 Bedrooms ; usual Domestic Offices ;
Outside and Inside Lavatories. Electrically equipped with
power and light. Brick-built Garage. 700 yards of Garden.
AN IDEAL HOUSE IN AN IDEAL SITUATION.
Prices from **£995** Freehold. **£50** Deposit; Balance on loan.

Call or write A. ROBINSON, Builder,
MOUNT VIEW, CEDAR'S ESTATE, RICKMANSWORTH
REPRESENTATIVE ON SITE WEEK-ENDS.

The Cedar's Estate
Advertisements for detached and semi-detached residences on the desirable Cedar's Estate, Rickmansworth, 'with prices starting from £995 Freehold'.

"IN METRO-LAND"
The Cedars Estate—Rickmansworth
(Subsoil—Gravel and Sand.)
100 *Trains daily—25 minutes journey by Metropolitan Electric service to Baker Street, and 'Through' City trains morning and evening.*

OWING to the popularity of this charming Residential district, with its lovely views, healthy surroundings and exceptional train service for the business man, development on the Cedars Estate is being rigorously pursued, and new roads made to afford a selection of sites upon which prospective purchasers can build their homes.

HOUSES
from
£1,065
to
£2,000

Price £1,250 Freehold—Deposit £100

IN order to assist those who cannot find a house to rent or who do not wish to disturb their capital, a system of purchase has been inaugurated, whereby a nominal deposit is payable and the balance as rent, thereby placing the occupier in the position of ultimate Owner, instead of a Tenant without interest in the property.

DEPOSITS
from
£65 to £200

OTHER ESTATES:—
KINGSBURY GARDEN VILLAGE,
CHALK HILL ESTATE, WEMBLEY PARK,
WEMBLEY PARK ESTATE,
ELM GROVE ESTATE, RUISLIP,
CECIL PARK ESTATE, PINNER,
GRANGE ESTATE, PINNER.

"WHERE TO LIVE," a new and profusely illustrated Handbook giving details of the Company's Estates, exclusive designs of various types of Houses, Terms of Easy Payment and how to Purchase Out of Income, also Train Services, Season Ticket rates, etc., can be had FREE OF CHARGE on application to

H. GIBSON
GENERAL OFFICES,
BAKER STREET STATION, N.W.1.
RICKMANSWORTH 182. LANGHAM 1139.

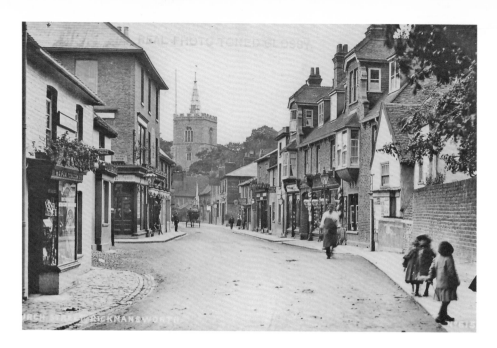

Church Street Looking South

An early postcard looking south with the tower of St Mary's church in the background. On the right-hand side, the sign advertising the premises of F. M. Pugh, practical certified watchmaker and jeweller, can just be seen, while a little further down the road is the King's Arms public house, where Walter Griffin was mine host. On the east side on the corner of Talbot Road is the hardware store of Beeson & Sons, where carpets were cleaned, remade and fitted, and old and valuable furniture 'carefully repaired and restored'. The shop was also an ironmonger's, as well as sanitary and domestic engineers. Their advertisement assured their customers of a 'quick delivery and prompt personal attention'.

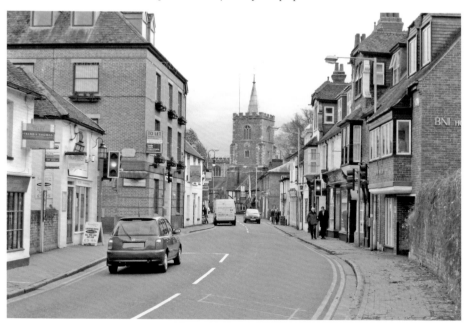

BEESON & SONS

(PARTNERS: STEPHEN B. BEESON, HERBERT BEESON),

The Hardware Stores,

Telephone 50. **RICKMANSWORTH.**

Ironmongers
Builders,
Sanitary and
Domestic
Engineers.

Complete
House Fitters
and
Furnishers.

House Decoration and Repairs of every description.

Sanitary Survey Department under management of
MR. S. E. BEESON, R.P., Mem. Sanitary Institute.

CARPETS CLEANED, RE-MADE & FITTED.

Inside and Outside Blinds Fitted or Re-made.

Old and Valuable Furniture carefully repaired and restored.

Beeson & Sons
An advertisement and a 1949
receipted bill of sale from the
hardware stores of Beeson &
Sons in Church Street,
Rickmansworth, to Mrs Kindsley
of Oxhey for a reconditioned
Hoover vacuum cleaner.

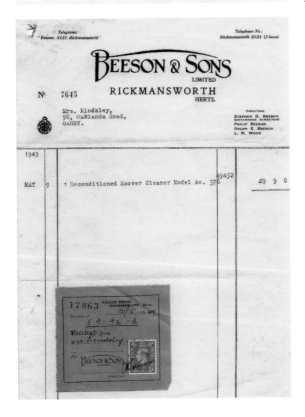

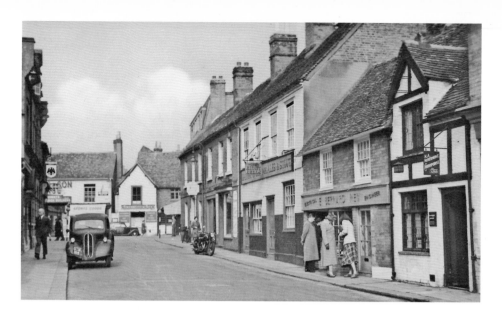

Church Street Looking North

With memories of the Second World War still fresh in people's minds, most commodities were still rationed and difficult to come by, although it was always worth keeping on the right side of the butcher and grocer in case anything was available 'under the counter'. Petrol was derationed in May 1950, which, taking the number of vehicles in view, probably dates this postcard to 1949 or early 1950. The shop window display of E. Bernard New, Electrical Contractor, appears to have caught the eye of a small group of passers-by, although with the tremendous shortages at that time, it's anybody's guess what it could have been. Next door at No. 9 is the practice of Miss N. A. McDermont, MSSCh, chiropodist, now occupied by the high-class bakers, Cinnamon Square. On the other side of Bernard New is the Eight Bells public house, while Barclays Bank can just be seen on the left adjoining the High Street.

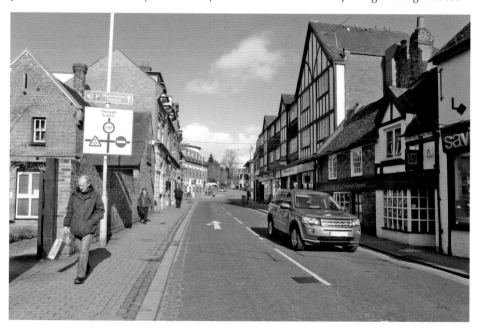

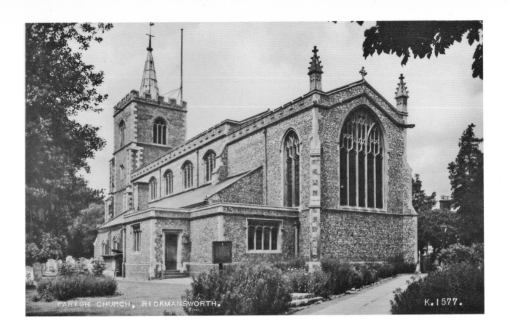

St Mary's Parish Church

Although the tower dates back to 1630, the early building of the parish church of St Mary the Virgin was rebuilt in the early nineteenth century due to its poor condition, with the consecration taking place in 1826. The new church could now accommodate 2,000 people. However, in order to harmonise with the architecture of the tower, the church was again rebuilt in its present form in 1888–90 to the design of Sir Arthur Blomfield at a cost of £5,675 6s 9d. The service of reopening was conducted by the Bishop of St Albans, the Rt Revd John Festing on Thursday 26 June 1890.

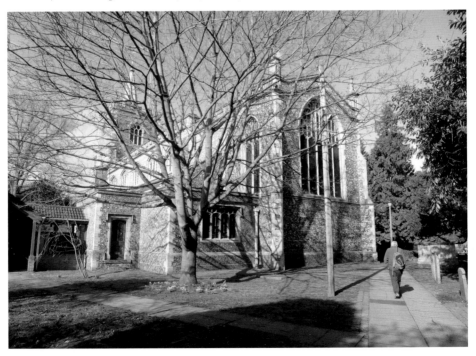

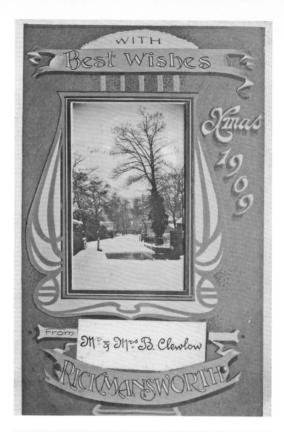

Christmas Card and Garden Fête
Above right is a 1909 Christmas card
from Mr and Mrs B. Clewlow to a Miss
Downes in Ealing. Below right is a
flyer for a garden fête and sale where
the Countess of Denbigh has kindly
consented to open the proceedings, which
will be held on Wednesday 14 June 1911,
and where a band will be playing during
the afternoon.

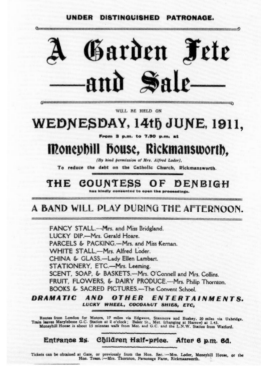

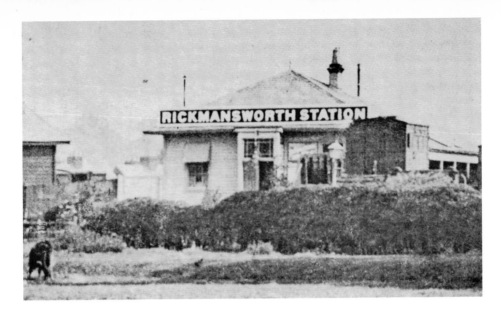

The Watford & Rickmansworth Railway

Following the ceremony of cutting the first sod at Tolpits Farm on Thursday 22 November 1860 by Lord Ebury, the formal opening of the Watford & Rickmansworth Railway, known as the Ebury line, took place almost two years later on Wednesday 1 October 1862. The brainchild of Lord Ebury, the railway company's first chairman, his vision was an extension from Rickmansworth to Uxbridge, but this idea foundered when the Great Western Railway (GWR) withdrew its promised subscription of £20,000 due to little enthusiasm, and the Uxbridge line never happened – the end of a dream. The Watford & Rickmansworth Railway was operated from the outset by the London & North Western Railway (L&NWR). Pictured above is the original timber Rickmansworth station, later replaced by the brick-built structure below. It was renamed Rickmansworth Church Street to differentiate it from the other station, which was constructed when the Metropolitan line arrived in 1887. The van up against the buffer stops to the right of the station above is a horse box used to transport horses and their grooms.

The Ebury Way and St Mary's Court
Now a popular walk and cycle ride, the disused trackbed of the old Watford & Rickmansworth Railway is seen right at the Rickmansworth end. It was called the Ebury Way after its innovator, Lord Ebury. Passenger services ceased on 2 March 1952, although a freight service continued until the line finally closed on 2 January 1967. The picture below, taken in early 2014, shows the residential accommodation of St Mary's Court, now occupying the site of the long-gone Church Street railway station, where steam trains once departed on the short journey to Watford Junction via Watford High Street.

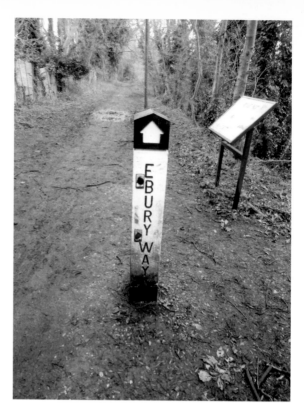

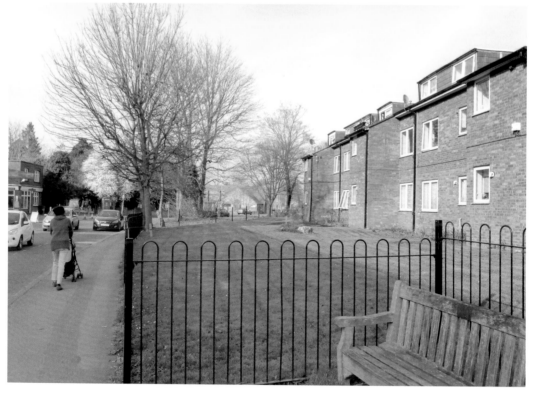

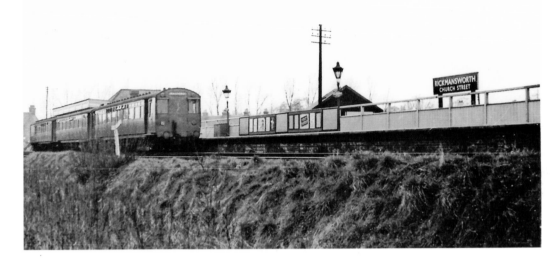

Rickmansworth Church Street Station
A nostalgic image of a three-car Oerlikon set at the Church Street station platform pictured shortly before the line's closure in 1952. The modern-day photograph shows the rear of Travis Perkins, a leading supplier to the UK building and construction industry, now occupying the site of the old railway sidings. St Mary's Court, where the station building used to be, can just be glimpsed in the background to the right of the picture.

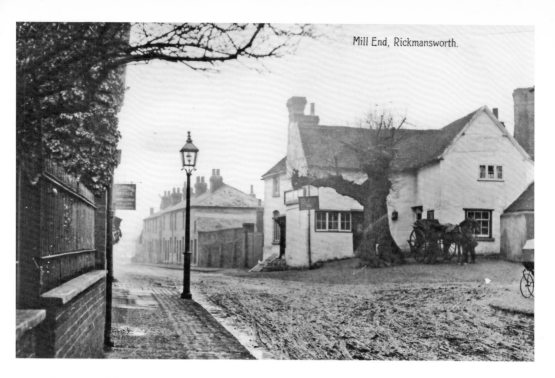

The Tree Public House, Mill End

This lovely, convivial old inn, dating back several hundred years and situated on the Uxbridge Road at Mill End, was once known as the Rose and Crown, but due to the large tree growing in the front, the pub was affectionately nicknamed 'The Tree' by the regulars. Following the death of Samuel Salter, the brewer, in June 1750, his son Stephen (1726–1800) started to acquire a number of tied houses, including the Rose and Crown in 1767. At some point after the elm was eventually felled, the pub was officially renamed The Tree.

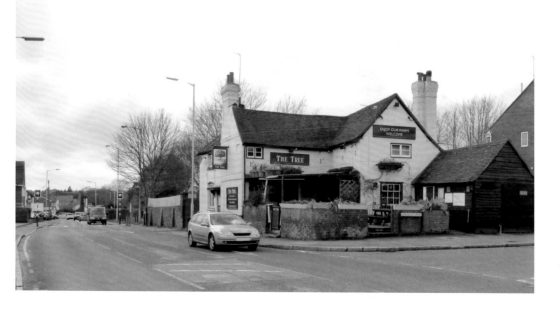

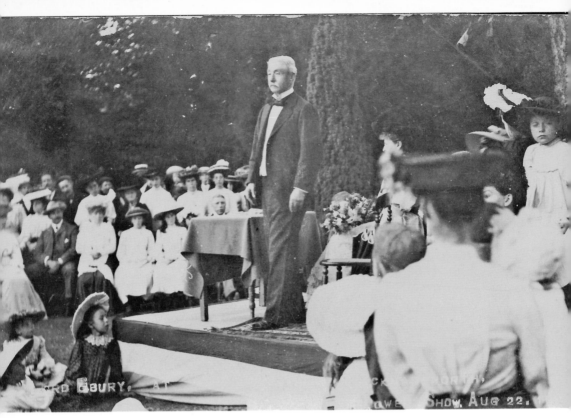

Rickmansworth Flower Show

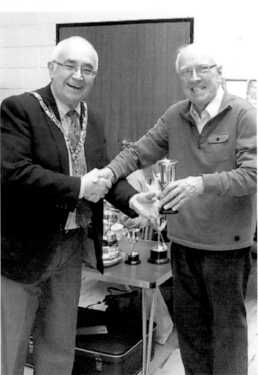

Wednesday 22 August 1906, a hot summer's day in Rickmansworth where Lord Ebury is seen above presenting prizes to the various winners in the local flower show. Gardening locally as a hobby became very popular between the two world wars – so much so that following the success of several shows in the early 1930s it was decided to form the Rickmansworth & District Horticultural Society in 1936. However, with the storm clouds of war gathering in 1939, it was felt that the cups and awards should be deposited at the local branch of Barclays Bank for safekeeping until the cessation of hostilities. With so many shortages during those dark days, the need to cultivate vegetables became ever more important as the members were encouraged to 'Dig for Victory'. Today, nearly eighty years after its formation, the society continues to thrive. Chairman Vic Hind, pictured left at the 2014 show, is presented with his trophy by Cllr Les Mead, chairman of Three Rivers District Council.

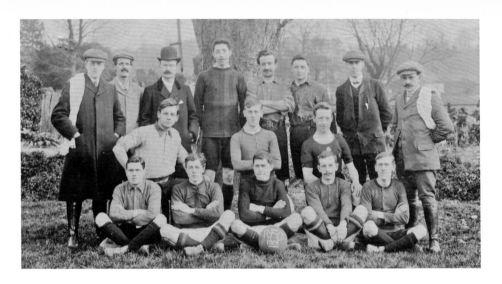

Rickmansworth *v.* Arsenal, 1956

With Rickmansworth Football Club posing for the photographer during the 1908 season, it does not seem possible that this proud club would meet up with the mighty Arsenal nearly fifty years later, but this is precisely what happened. It was in April 1956 that the Gunners visited Rickmansworth for an evening match as a thank you to the club for team goalkeeper Jim Standon, whom they had signed three years previously. Club expenses were high, especially the cost of travelling to various fixtures, etc., and the promise of such a high prestige game would certainly improve their finances. In anticipation of a record crowd, the ground at Scotsbridge Meadows was fenced and a gate installed, the outcome indeed resulting in an excellent turnout, although the final score was 1-4 to Arsenal. The Ricky squad, including local centre-half player Rod Branford, in that memorable game are pictured below. Rod is third from the right in the front row.

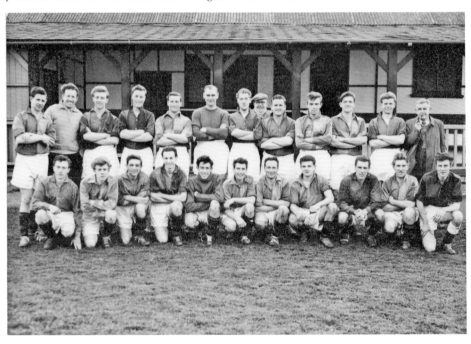

WELL SAVED

Rickmansworth Town Football Club

After the original club closed in 1968, Rickmansworth Town FC was reformed in 1993 by the late Rick Valentine as an under-18 Youth Team. It was formed by players that had all been members of the successful Chiltern United Youth Football Club that was based at the Royal Masonic School for Girls from 1986. In September 1995, the club became members of the much respected Watford Sunday Men's Football League, and started their new venture in Division 6 as a somewhat naive over-18 team. With ageing players, most of who were now over thirty years old, the decision was reluctantly made to merge this team with Old Fullerians FC, which was originally established in 1982 by former pupils of Watford Boys Grammar School. However, it did not take long for a 'new' Rickmansworth Town FC to emerge (for the third time) in September 2012 as a 'vets' team for players over the age of thirty-five. This team is based at the Newland Park Campus in Chalfont St Giles and is currently enjoying their first season at the top of the Mid Herts Vets League under the expert guidance of club chairman, Brian Donnelly.

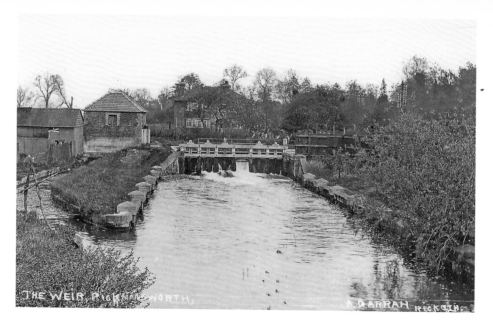

The Weir

The weir above was built in 1896 on this attractive part of the River Chess that runs parallel with what was then the Grand Junction Canal. Just out of camera shot in the above picture, but seen below in the modern image, is part of what used to be The Boat public house. There were once two pubs at differing levels. The Boat was adjacent to the canal towpath and served the needs of the boat people who travelled along this stretch of waterway, which is now the Batchworth Lock Canal Centre. The Railway Tavern was at street level and catered for the railway workers and passengers homeward bound from the nearby Church Street station.

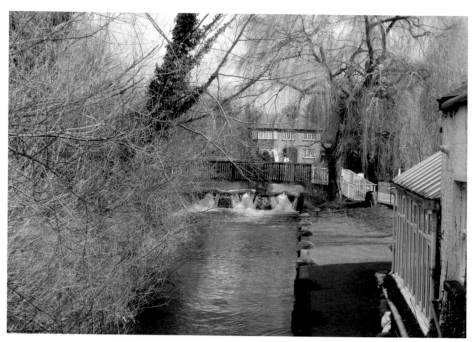

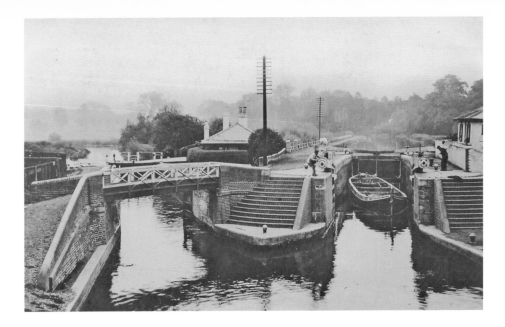

Batchworth Lock

One of the most well-known and photographed places in Rickmansworth must be that of Batchworth Lock on the Grand Union Canal, seen here from the bridge in Church Street. Around the early part of the nineteenth century, several branches of the Grand Junction Canal (as the waterway was then called) were constructed at Rickmansworth. The left arm at Batchworth, known as Salter's Cut, was built by Salter's to give entry to their brewery, which was sited close to the town wharf, while the right lock catered for all other waterway traffic. The throngs of people gathered at the lock on a spring weekend are seen below, enjoying part of the May Rickmansworth Festival, which is held annually in the Aquadrome and along the canal towpath from Batchworth Lock to Stocker's Lock.

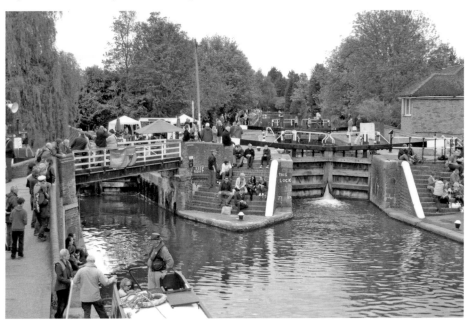

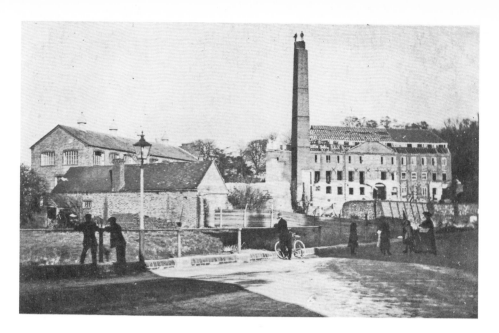

Batchworth Mill

Originally owned by Thomas Buller in 1759 for the weaving of cloth and silk, the mill was purchased in 1818 by John Dickinson, the manufacturing stationer, who took over the site for the production of half-stuff, the raw materials used to make the finished paper. When Batchworth Mill eventually closed, most of the buildings (except the one in the background on the extreme left) were demolished in 1910, but just before the chimney came down, local photographer T. J. Price seized the opportunity to take some excellent pictures of the surrounding area from the top. The site was then purchased by the Rickmansworth & Uxbridge Valley Water Company for their new offices and pumping station. The remaining building of the old mill is prominently depicted in the modern-day picture below.

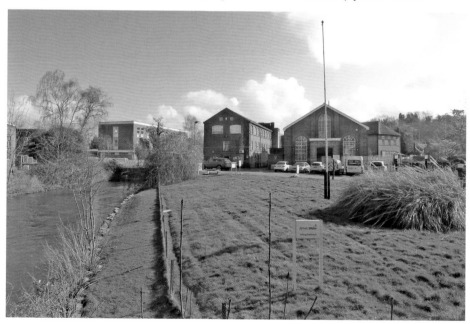

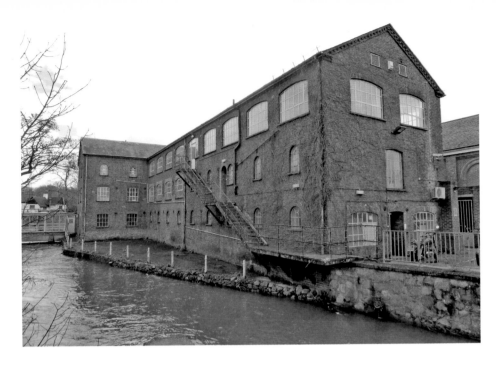

The Old Mill Building

Seen above is the last remaining building of Batchworth Mill used by both Affinity Water, who now occupy the site, as part of their sports and social club, and by the Batchworth Lock Canal Trust for educational purposes. The 2014 image below was taken from one of the first-floor windows of the old mill, and shows the River Colne with the White Bear public house on the left.

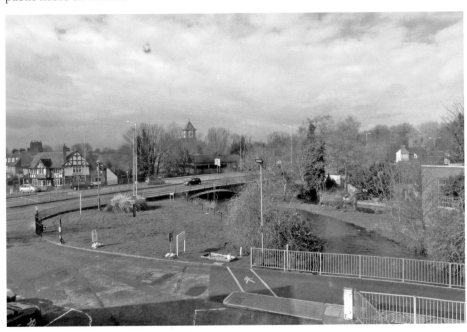

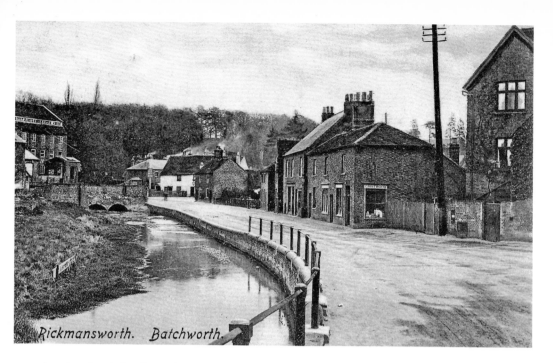

Rickmansworth. Batchworth.

London Road, Batchworth

Posted on 22 July 1905, the card above shows part of Batchworth Mill on the left with the millstream running down the side of the road. A year later, in 1906, the stream was culverted and diverted into the River Colne for the widening of London Road. The white building of the Coach and Horses public house can be seen in the background, while Lady Ebury's Dower House is pictured on the extreme right, with Harefield Road just out of camera shot. Today, with a dual carriageway being constructed in the 1970s, the same view has changed out of all recognition.

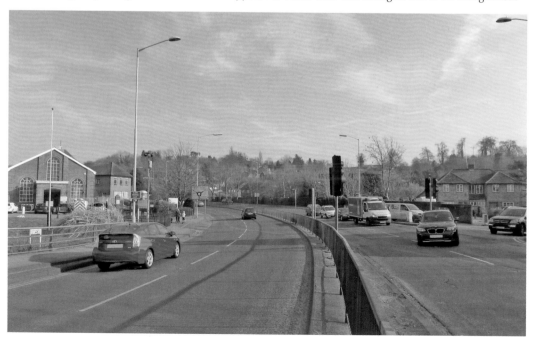

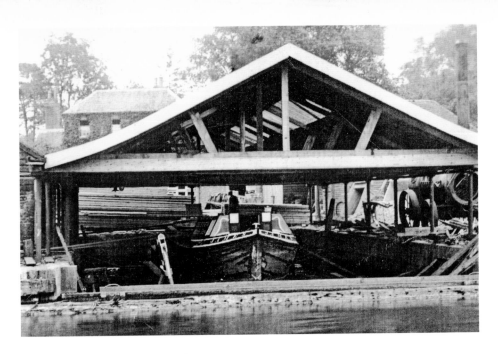

W. H. Walker & Brothers Ltd (1)

It was on Tuesday 6 June 1905 that young Harry Walker took over a lease on part of Frogmore Wharf on the Grand Junction Canal, Harefield Road, starting a successful business that would endure for the next eighty-four years. Not only were Walkers of Ricky (as they were known) builders' merchants, timber merchants and coal and coke merchants, they also had a fine reputation as boat builders, as can be seen in these two images, contributing greatly to the history of the inland waterway system. The bottom picture shows the caulking of the seams to a Star class motor boat in 1934. The first boats built were horse-drawn, but motor power was later introduced from 1913.

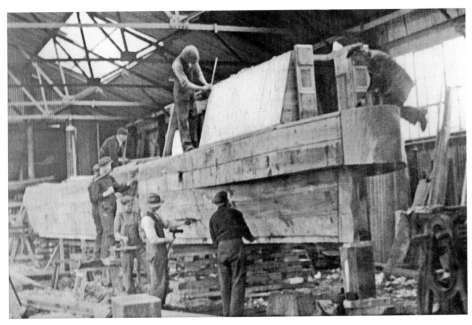

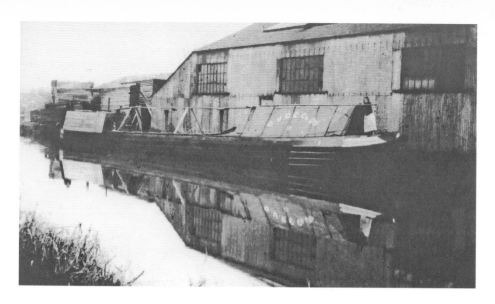

W. H. Walker & Brothers Ltd (2)

With boats for hire in the foreground, the steam launch *Gadfly* (*below*), belonging to Alfred Walker, makes its way across Batchworth Lake towards Frogmoor Wharf, just visible in the distance. The photograph above depicts a motor boat moored at Frogmoor Wharf in the 1920s. All three lakes were originally old gravel pits, some of the material allegedly being used in the construction of the original Wembley Stadium. In 1913, the Walkers purchased the freehold of Batchworth Lake for £3,600 from Lord Ebury for boating and pleasure activities, but fifteen years later, an organisation called the Aquadrome Company bought both Batchworth and Bury Lakes. The third lake, Stocker's, is a beautiful and peaceful location of approximately 100 acres, two thirds of which is water with islands. It is bounded on the south-east by the Grand Union Canal and on the north-west by the River Colne. It is owned by Affinity Water Ltd with the Friends of Stocker's Lake (FoSL), established in 1990 to conserve and enhance the area as a nature reserve. The natural beauty of the whole of this delightful place stands today as the jewel in Rickmansworth's crown.

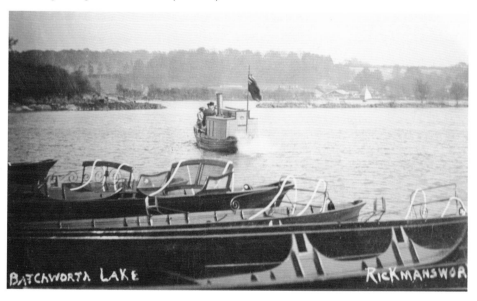

W. H. Walker & Brothers Ltd (3)
Today, with narrowboats moored on the
Grand Union Canal and Walkers of Ricky
long gone, a Tesco supermarket now
occupies the Frogmoor Wharf site, a sad day
indeed for Rickmansworth when the firm
closed in 1989.

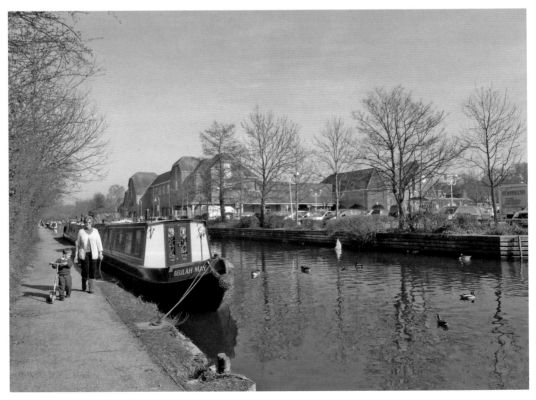

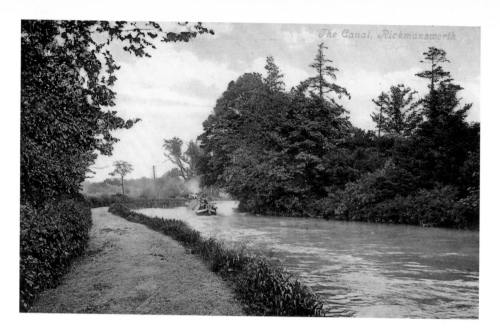

The Canal, Rickmansworth

This idyllic scene on a picture postcard was sent on 20 August 1907 by 'S&M' to a Miss Hay in Brockley. The message read, 'Dear Girls, We are having a very good time here and the country is lovely. We are going for a long walk by this canal towards Watford. Hope we shall not fall in, in our excitement.' One of the main obstacles that confronted the boatmen in the early days of a journey up and down the canal system were the tunnels. The horse had to be unhitched and led over the hill to rejoin the towpath on the other side, while two men lay on their backs with their feet on the surface of the roof and literally 'walked' the boat through the tunnel. This was known as 'legging' and was a hard and arduous experience, especially as the only light was that provided from a flickering candle. A small group of boat people, or 'boaters' as they call themselves, are seen below chatting, probably about the day's events or how far they have travelled.

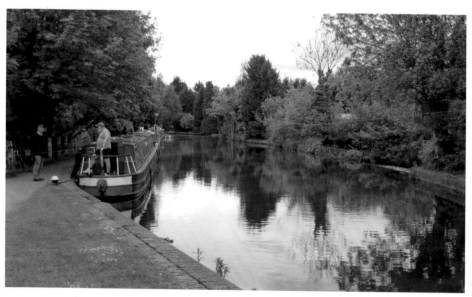

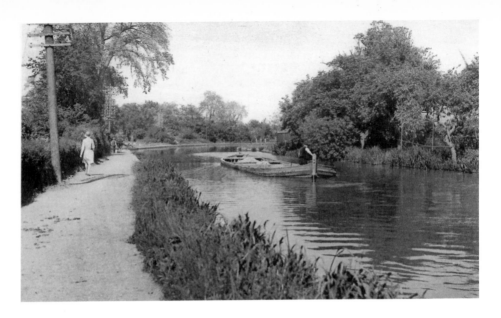

The Rickmansworth Festival (1)

From a horse-drawn working boat above in the 1920s to the effervescent carnival atmosphere of the grand finale to Ricky Week in 2013 – the Rickmansworth Festival. Taking place on the third weekend in May each year at the Aquadrome and on the canal towpath from Batchworth to Stocker's Locks, the venue attracts a lovely array of narrowboats from across the country, moored up to three abreast and all proudly flaunting colourful decorations of flags and bunting. Many have interesting histories, with several no doubt having been built by the now defunct local boatbuilder, W. H. Walker & Brothers Ltd. Some of the boats have various wares and crafts on display that the numerous passers-by can purchase at reasonable cost.

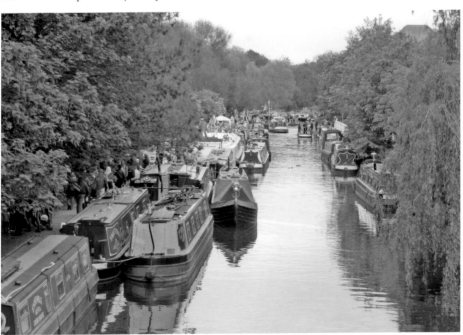

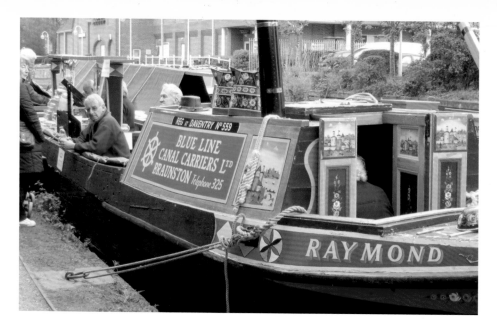

The Rickmansworth Festival (2)

Raymond, the superb craft seen above, was commissioned by the Samuel Barlow Coal Company Ltd and built at Braunston, Northamptonshire, in 1958, the last unpowered working narrowboat to be constructed there, and probably the last to be built in Britain. It was launched in true canal tradition by smashing a quart bottle of cider against the side. *Raymond* then underwent a busy working life, initially transporting coal from Baddesley Wharf on the Coventry Canal to John Dickinson's paper mills. Following the decline in work on the canals, *Raymond* was now showing the ravages of time. After extensive restoration costing in the region of £60,000, the old narrowboat has been returned to her former glory, testament to the loving care bestowed on her by a great many dedicated people. Below, the popular Phoenix Jazz Band is seen just about to disembark after entertaining the crowds on the towpath.

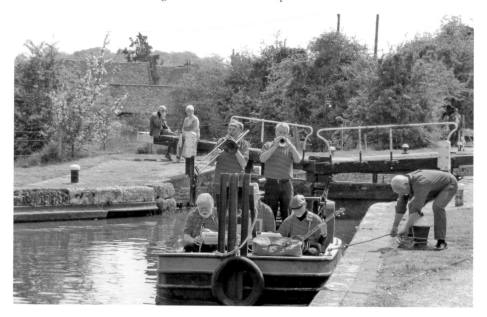

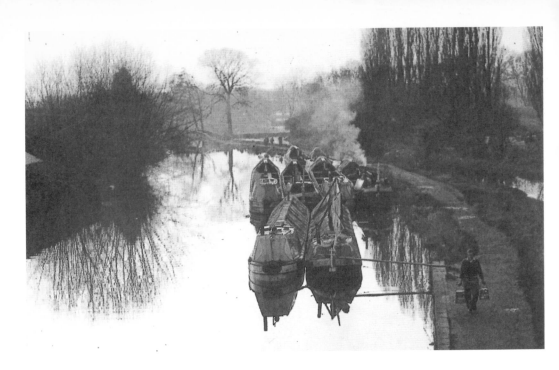

Dusk on the Canal

A tranquil scene on a peaceful stretch of the Grand Union Canal at Rickmansworth, taken in the autumn of 1969, as one of the boat people is seen walking along the towpath in the twilight with two buckets. Over forty years later, the vista is replicated below as a number of narrowboats have moored for the night on a spring evening in 2013.

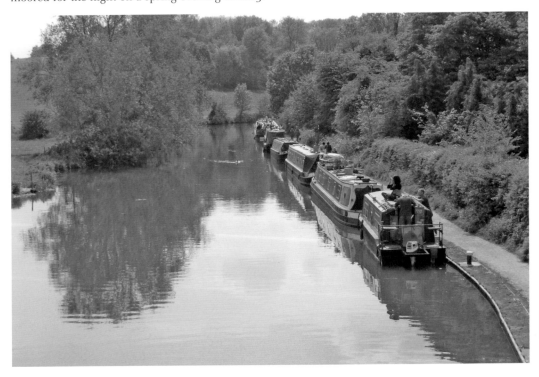

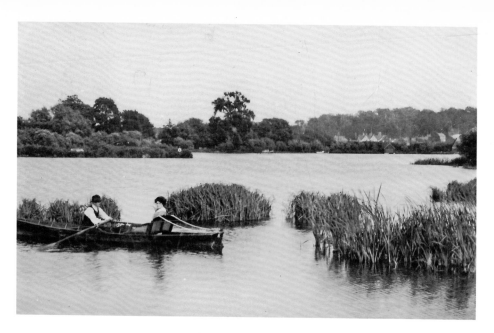

A Leisurely Afternoon on the Lake

Written in the early part of the First World War on 3 April 1915, this postcard depicts a leisurely view of a young couple enjoying a quiet hour on Batchworth Lake in a boat probably on hire from the Walker Brothers, who had purchased the lake just two years previously. Nowadays, Batchworth Lake is fished and home to the waterskiing club, while the adjoining Bury Lake is used for windsurfing, sailing and canoeing. The small, powered boat below was used as a ferry service on Bury Lake for visitors to the Rickmansworth Festival, who wished to be transported from the boathouse to the fairground amusements on the other side.

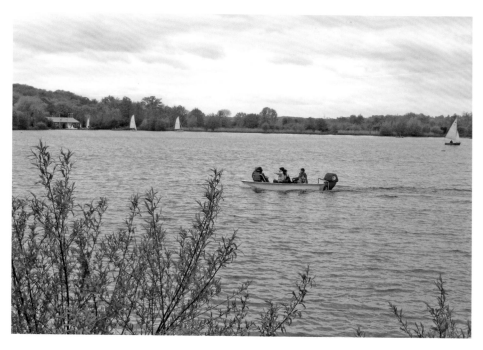

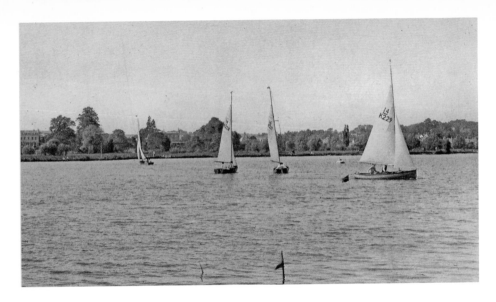

Rickmansworth Sailing Club/Bury Lake Young Mariners

It was over eighty years ago, in early 1930, that the first seeds were sown by a small but dedicated group of sailing enthusiasts to form the Rickmansworth Sailing Club at Bury Lake, part of the Aquadrome complex. The club thrived but, after twenty-nine successful years, ultimately vacated the site in April 1959, moving to their new and much larger home, Troy Lake, situated a few miles away just off the main Rickmansworth/Denham road. In 1960, the Hertfordshire County Council set up a school sailing base at Bury Lake, with HCC providing staffing and funding, but this support was withdrawn in 1982 due to public expenditure cuts. It was then that the Bury Lake Young Mariners (BLYM) was evolved, aiming to promote the development of young people through the medium of sailing and related activities. With many fundraising initiatives, this has resulted in a high-quality fleet and comprehensive facilities ashore as this superb sailing club, and the school goes from strength to strength. The club is now one of the largest all-voluntary clubs and training centres in the country.

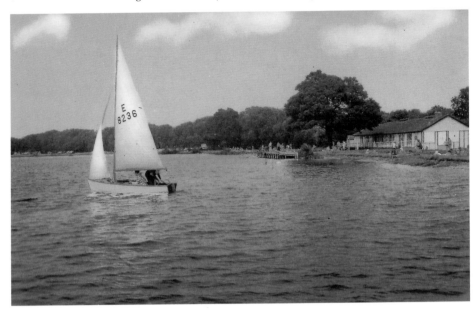

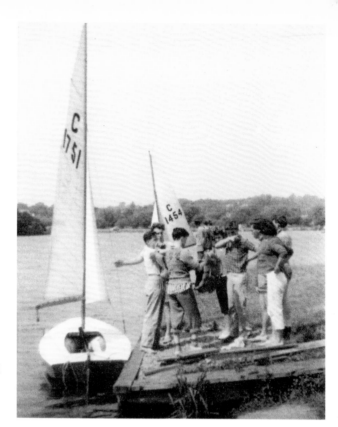

Messing About in Boats
An early picture showing a group of young people, seen right with a Cadet Class dinghy, looking forward to a day's sailing on Bury Lake under the expert tuition of an experienced club member. The photograph below depicts the slipway with the boathouse on the right.

MOOR PARK ESTATE, HERTS.

MOOR PARK STATION is 25 minutes from BAKER STREET *FREQUENT ELECTRIC EXPRESSES to and from the CIT*

A MAGNIFICENT ESTATE

of well-timbered undulating parkland, through which avenues have been formed, commanding incomparable views over the surrounding country.

THE COUNTRY CLUB

with its Three Eighteen-hole Golf Courses, Grass and Ha Tennis Courts and Gardens forms a central feature arou which the development is planned.

ADMIRABLE SITES

Available to suit purchasers' individual requirements or upon which houses will be built at an inclusive cost.

DISTINCTIVE HOUSES

nearing completion, two of which are here illustrat may be inspected at any time, week-ends include

MAIN DRAINAGE	COMPANY'S WATER

ELECTRIC LIGHT	TELEPHONE GAS

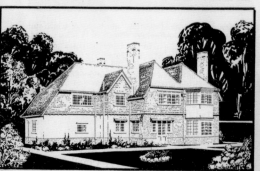

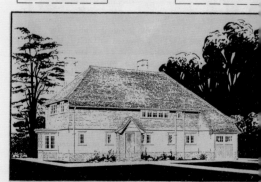

Further particulars and Plans of Freehold Houses
Land, may be had

The Estate Surveyor,

(of which the above are typical examples) and on application to

Moor Park, Herts.

Phone: Rickmansworth 217. London Office: City 57

Moor Park Estate, Herts

The magnificent Moor Park Estate, where houses are complete with main drainage, electric light, telephone and gas. A country club with golf courses, tennis courts and garden form a central feature of the developement.

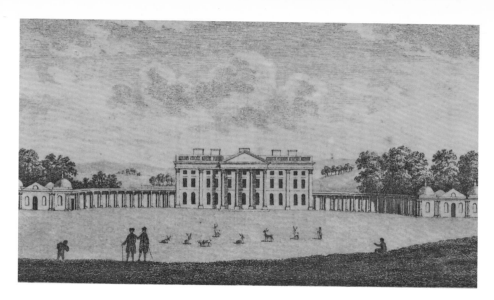

Moor Park

The original mansion was built around 1678 for James Scott, the 1st Duke of Monmouth. In 1720, the Duchess, now a widow, sold the estate to Benjamin Heskin Styles, a city speculator, who then set about improving the house, so much so that the original structure completely disappeared under the transformation. The next occupant in 1754 was Lord Anson, who employed the celebrated Lancelot Brown (better known as Capability Brown) to landscape the gardens. Eventually, Robert Grosvenor, the 1st Lord Ebury, inherited Moor Park from his mother, the Marchioness of Westminster, in 1846. Like all his predecessors, he began by making many alterations to the house. Today, this magnificent mansion and the estate is set in 300 acres of mature woodland and superb parkland and is now an exclusive golf club and conference centre.

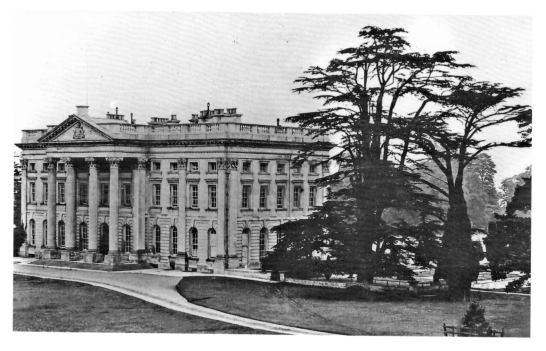

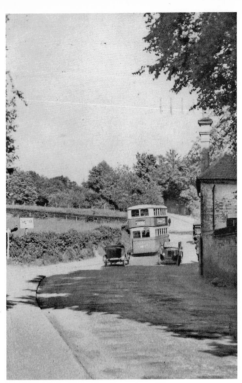

Scots Hill

Scots Hill on a sunny summer's day in the mid-1930s, when the road was just a single carriageway. Part of Scotsbridge House can be seen on the right, once the home of Vice Admiral, the Hon. Josceline Percy, who had once served briefly under Admiral Lord Nelson on HMS *Victory*. Vice Admiral Percy lived at Scotsbridge House until his death, aged seventy-two, on 19 October 1856. The house is now the home of Holstein UK – Holstein & British Friesian, whose offices have occupied the premises since the early 1950s. Scots Hill was made into a dual carriageway in 1972, with the 'down' side the original road.

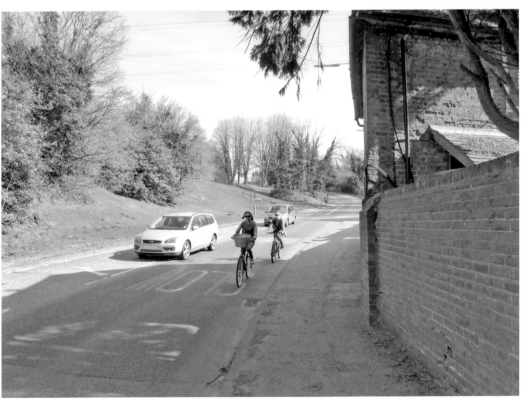

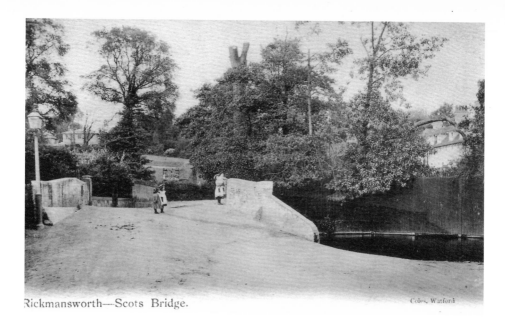

Rickmansworth—Scots Bridge.

Coles, Watford

Scots Bridge

A tranquil scene captured in the early part of the twentieth century is depicted at the bottom of Scots Hill, where the River Chess lazily flows under Scots Bridge. No traffic worries for these children standing in the road, unlike today, where a constant stream of lorries and cars travel down the hill and over the bridge, which has changed out of all recognition from how it used to be due to the construction of the dual carriageway in 1972. Highfield House, the home of Mr W. E. Catesby, can be seen on the left-hand side, while a board proclaims that houses are for sale or to let in Copthorne Road. Scotsbridge House can just be seen through the trees on the right.

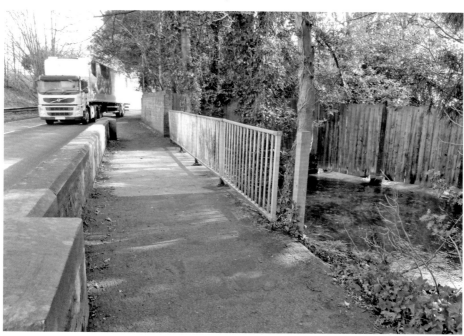

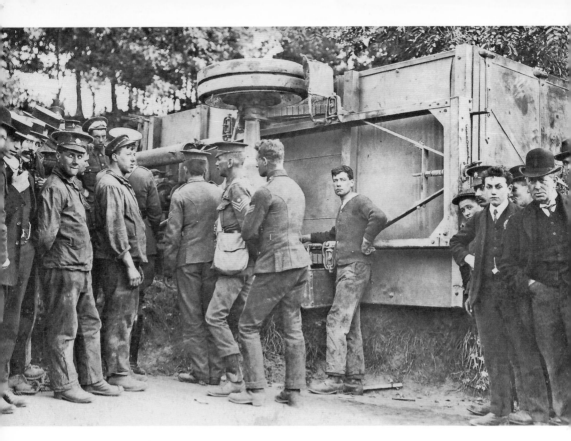

Accident on Scots Hill

Around 2 p.m. on Sunday 22 September 1912, two large motor lorries attached to the 57th Company Army Service Corps, laden with a considerable quantity of stores, were proceeding down Scots Hill, the scene of many bad accidents, on their way from Newmarket to Aldershot, when the brakes of the second vehicle failed. Rapidly picking up speed, the lorry crashed into the rear of the leading motor with such force that it careered through an iron fence onto land belonging to Mr W. E. Catesby. The second motor was turned in the opposite direction through another iron fence, where it subsequently overturned. Fortunately, no one was hurt, but a motorbike and sidecar coming up the hill were completely wrecked. The motorcyclist and his passenger, seeing the approaching danger, managed to jump clear in the nick of time. With the police now in charge of the situation, and the road practically blocked for over three hours, the two lorries were eventually cleared by the aid of an army traction engine.

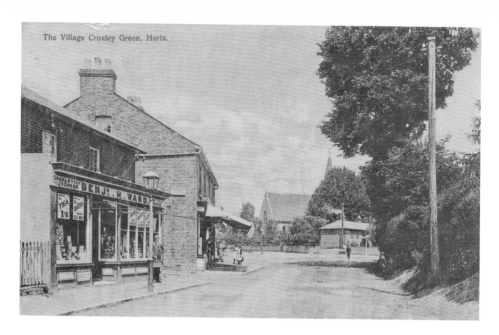

The Village Croxley Green, Herts.

Top of Scots Hill

A postcard that was sent on 8 August 1910 by a resident of Dickinson Square shows All Saints church in the background with several shops on the left, including the premises of Benjamin H. Ward, grocer's and post office. One of the advertisements in the window proclaims that selected groceries are on offer ('Best Value for Money'), while another indicates that 'Special Tea at 1/6d' is available. A sign on the wall next door advertises the trade of A. J. Bates, 'Builder and House Decorator'. Remarkably, the view below, taken over 100 years later, appears to have changed very little, apart from shop names, road markings and the ever-present motor car.

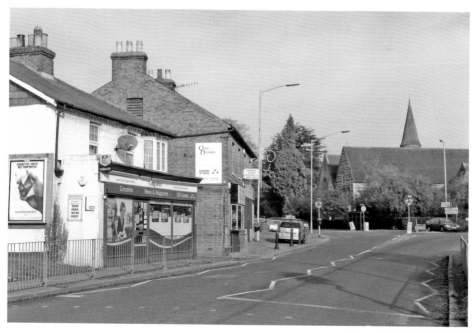

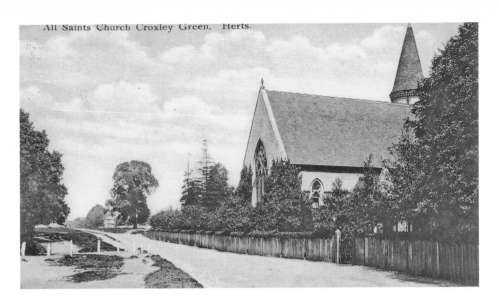

All Saints Church, Croxley Green

The foundation stone of the nineteenth-century chapel of ease was laid by Lord Ebury on Tuesday 27 September 1870. Described as 'early English style' or 'first pointed Gothic', the church was consecrated on Tuesday 25 June 1872 by the Rt Revd Bishop of Rochester, Thomas Claughton, due to the church being in the Diocese of Rochester. When the Diocese of St Albans was formed five years later, Thomas Claughton was appointed their first bishop. During the dark days of the Second World War, on 25 September 1940, a parachute mine was dropped on the church, causing severe damage to the tower, roof and the Lady chapel, along with other destruction. Memorial plates dedicated to those employees of John Dickinson, the owner of the local paper mill, who lost their lives in both world wars, can be seen on the outside south wall of the church.

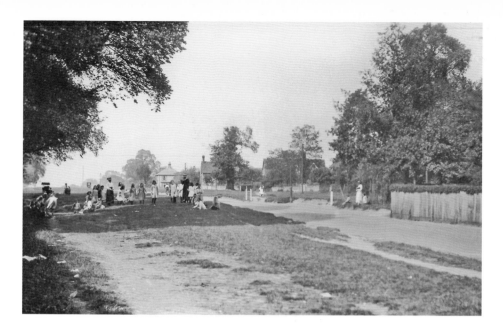

The Croxley Revels

Looking along the green from All Saints church, a group of children, possibly a Sunday school outing, have paused for a while for games and maybe even a picnic in this early 1900s photograph. Less than twenty years later, in 1920, the first midsummer Croxley Revels were held on the green, the start of a superb annual tradition that thrives and continues to this day. An action-packed afternoon is guaranteed for all, from the young to the not-so-young. Following the grand procession that wends its way around Croxley's streets, thronged with cheering bystanders, and the crowning of the Revels Princess, there are numerous stalls and activities to enjoy, ranging from maypole dancing and the famous inter-schools pushball tournament to traditional Punch and Judy shows and performances by local dance groups – in fact 'all the fun of the fair'.

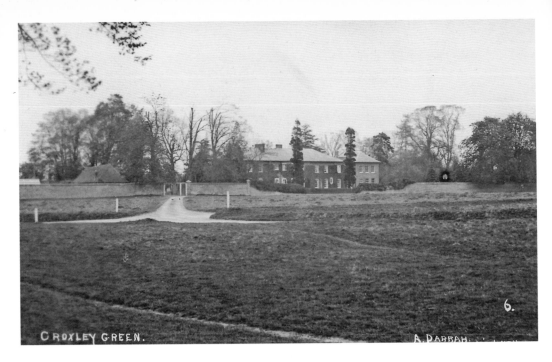

CROXLEY GREEN.

A. DARRAH.

6.

Croxley House

Constructed on the site of an earlier building, Croxley House was purchased in 1767 by Thomas Villiers, Lord Hyde, who became the 1st Earl of Clarendon in 1776. On his death in 1786, the title then passed to his son, also Thomas, who became the 2nd Earl and also inherited the property. During the Second World War, the house was leased to St Dunstan's, the charity for the blind, and in 1949, was bought by the Women's Voluntary Service. Today, this lovely old building in its tranquil setting offers care and accommodation for elderly people.

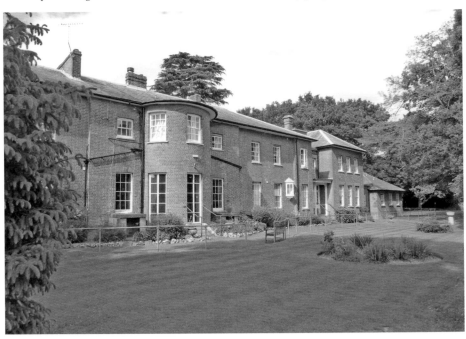

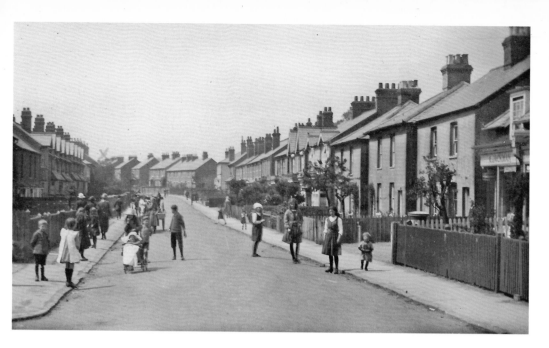

New Road

An early twentieth-century snapshot of New Road at the junction with Dickinson Square, where a group of children are seen at play, something that would be impossible with today's busy traffic. The arrival of the photographer appears to have generated some inquisitive interest, though – enough to momentarily divert their attention from the childhood street games of the period. The 2014 image also proclaims an equally quiet vista, although this was a lull in what is normally a busy thoroughfare.

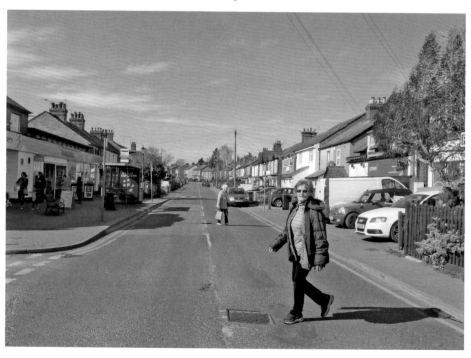

The Institute

Situated on the corner of Dickinson Square and New Road, the institute was built by John Dickinson for his employees at the local paper mill as a place of learning, where committee meetings and educational evening classes were held, as well as recreational activities, such as dancing and the performance of plays. The institute was destroyed by fire in the mid-1960s, and the Guild House, a block of fifteen flats, now occupies the site.

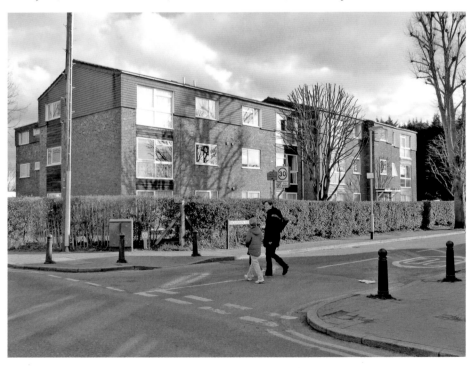

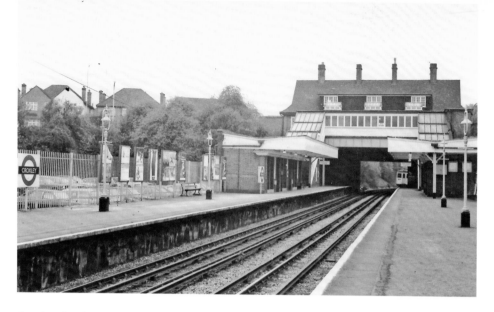

Croxley Station

Croxley station on the Metropolitan branch line to Watford, seen above in the 1980s, was formerly called Croxley Green but was renamed 'Croxley' on 23 May 1949 to differentiate it from the now closed L&NWR Croxley Green station to the west of Watford. The station opened in November 1925 as part of the extension from Moor Park. The train depicted in the photograph below, taken on 13 November 2013, is a S8 Stock in its red, white and blue livery manufactured by Bombardier Transportation. These trains entered service from 31 July 2010. The 'S' designation stands for sub-surface and the '8' represents the number of cars (i.e. an eight-car train). All the Metropolitan line trains are S8s.

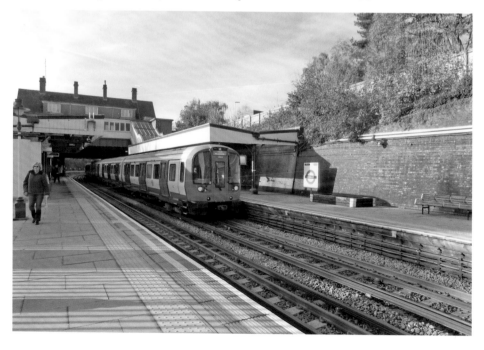

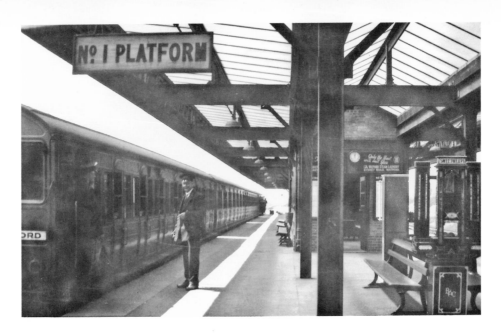

No. 1 Platform – Watford Metropolitan Station

An early photograph of one of the platforms at Watford Metropolitan station in Cassiobury Park Avenue, probably shortly after the station's opening in 1925. Note the slot machine advertising the sale of sweetmeats on the right of the picture. Below is the same platform in 2010, and a small group of young passengers are racing to catch their train before its imminent departure. This is one of the long-serving A60 trains, a very successful design.

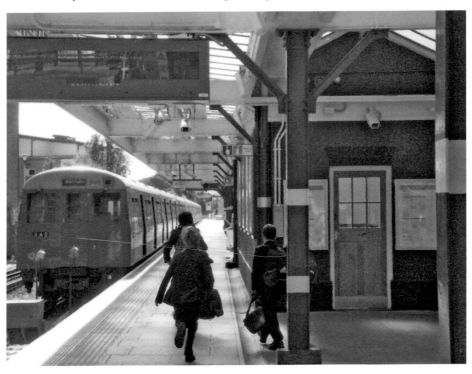

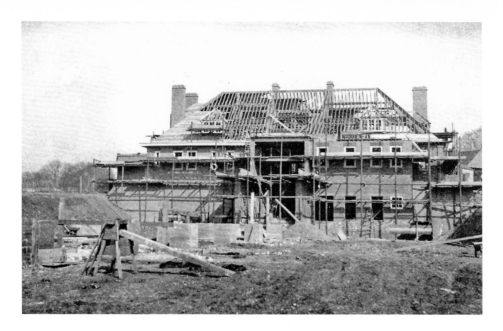

Watford Metropolitan Station

The station in Cassiobury Park Avenue, seen here under construction, was opened on 4 November 1925, and is the terminus for the branch line from Moor Park. Although ending at Watford, it was originally intended, but never constructed, to continue into the town centre as Watford Central. The proposed station building in the High Street opposite Clarendon Road is now occupied by a public house. Work is currently being implemented on a new railway engineering project to divert the line away from the existing Cassiobury Park Avenue terminus, which is destined to close, to use the old trackbed between Croxley Green and Watford Junction, the proposed new terminus. Unfortunately, the closure will be a devastating blow to local commuters and the schoolchildren who use the line, although many will eventually travel from the new station at Cassiobridge.

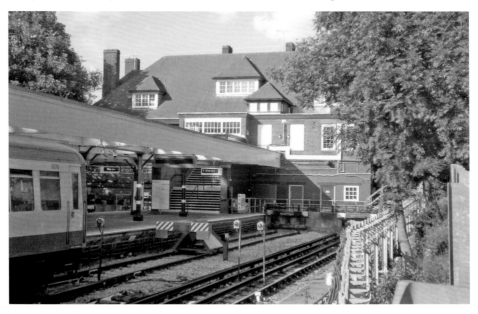

THE LYNWOOD
LADDER & JOINERY WORKS

FOR ALL TYPES OF

SPECIALISED JOINERY

ALSO

MANUFACTURERS OF THE

"LYNWOOD ACE"
22 ft. CARAVAN, A COMPLETE
HOME ON WHEELS

Trade Enquiries Invited

Works: **L.M.S. Goods Yard**
CROXLEY GREEN
Phone:
GADEBROOK 2152
HERTS

The Lynwood Ladder & Joinery Works
'All types of specialised joinery undertaken and manufacturers of the "Lynwood Ace" caravan – the complete Home on Wheels.'

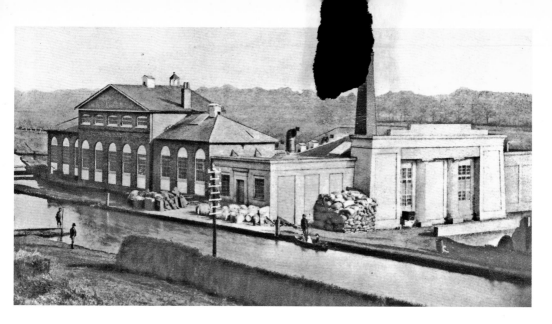

Croxley Mill (1)

Following the acquisition of sites for several of his paper mills, including Apsley, Nash and Home Park, John Dickinson (born 29 March 1782) turned his attention to Croxley, where a new mill opened in 1830. Because Lord Ebury, who lived at nearby Moor Park, objected to the view that he had of the mill, Dickinson provided an Egyptian frontage, with two huge columns and an entablature of painted stucco, that was more pleasing to the eye. In 1836, John Dickinson built himself a fine house called Abbot's Hill at Nash Mills, where he lived with his wife Ann and their seven children. Dickinson died on 11 January 1869, aged eighty-six. With Croxley Mill long gone, the site is now occupied by the Byewaters housing estate.

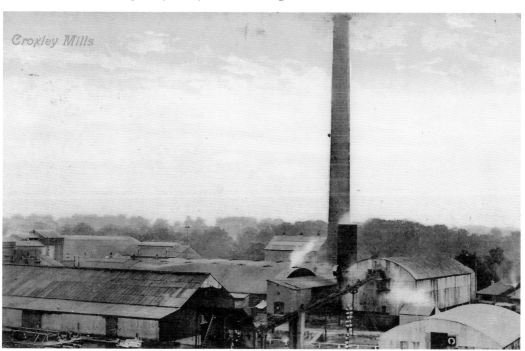

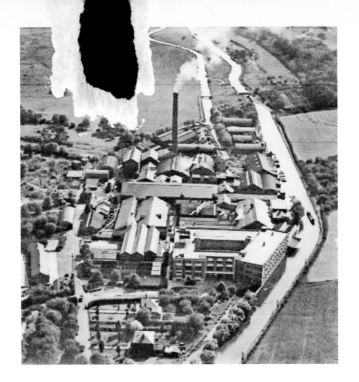

Croxley Mill (2)

An aerial view of Croxley Mill is seen above, taken on 30 June 1926. The Grand Junction Canal running alongside was of vital importance before the coming of the railway for the transportation of incoming and outgoing materials and goods. The picture was taken shortly before the amalgamation with several other waterway companies to form the Grand Union Canal in 1929. The snapshot, taken across the towpath and canal on 8 March 2014, shows part of the Byewaters Estate.

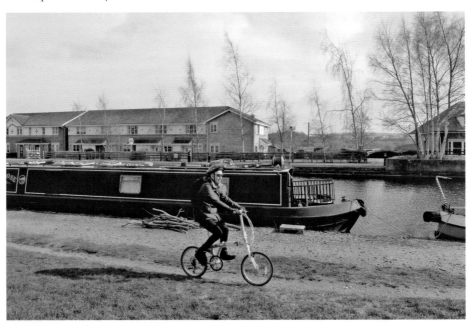

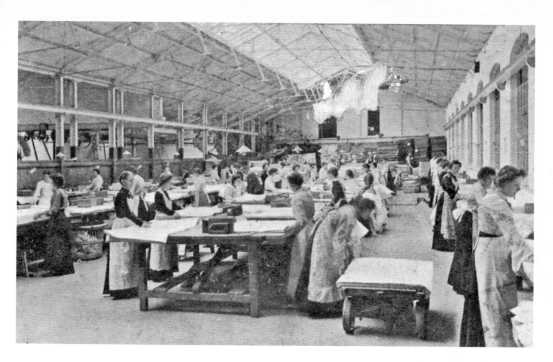

Croxley Mill (3)

The above postcard, which was sent on 26 May 1909, depicts the Paper Sorting House at Croxley Mill, and appears to show all the hallmarks of a clean and well-organised working environment. The other card shows two working narrowboats, *Petrel* and *Moon*, tied up at the mill on the Grand Junction Canal, waiting to unload their cargo of raw materials.

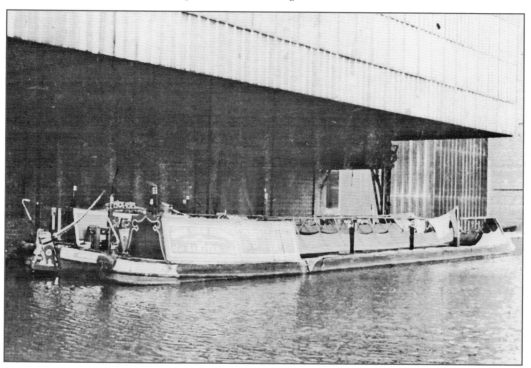

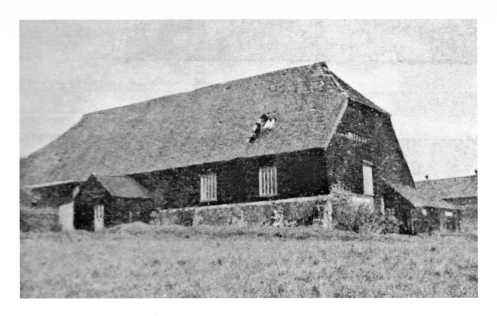

Croxley Great Barn

This magnificent Grade II-listed threshing barn, dendro-dated back to the winter of 1397/98, is one of the oldest and largest of its type in Hertfordshire, measuring 101 feet by 40 feet. The barn, which is now obscured by high hedges, is sited near to Croxleyhall Wood, and is a timber-framed, five-bay, aisled building with a crown-post roof – the doors within the porch were once large enough for a fully laden haywain to pass through over the 4-inch thick oak flailing floor. In 1972, the ownership of the barn was transferred from Gonville and Caius College, Cambridge, to Hertfordshire County Council, who renovated it between 1972 and 1975. It was then leased to St Joan of Arc School until 1995 when the ownership was passed, at no cost, from the county council to the governors of the school. A further change of tenure took place in 2013, when the barn was transferred to a separate trust to avoid any financial liability to the school.

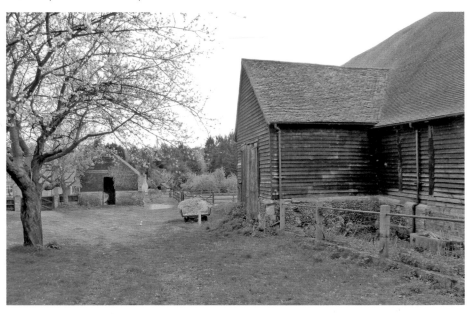

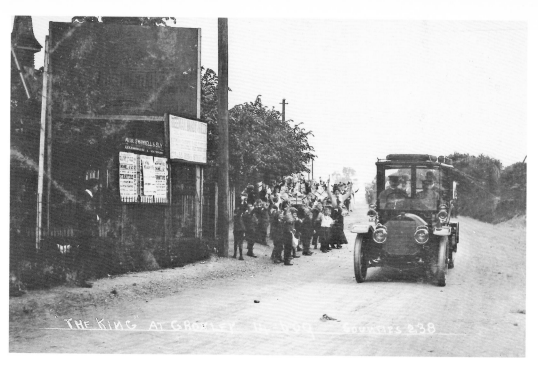

"THE KING" AT GROXLEY 14-6-09 — SOUVENIR 238

The King's Visit to Croxley Green

Croxley residents were out in force on Monday 14 June 1909 to welcome King Edward VII, whose small cavalcade of vehicles passed through Croxley Green. No doubt His Majesty was making a short 'Saturday to Monday' visit, as the weekend was then called, to his friend the Earl of Clarendon, whose country estate was at The Grove near Watford. What is most noticeable from this historic image, when compared to modern-day safeguards, is the complete lack of security, as the loyal spectators press forward to cheer and wave their sovereign on his way. Sadly, less than a year later, on 6 May 1910, the King died, aged sixty-eight.

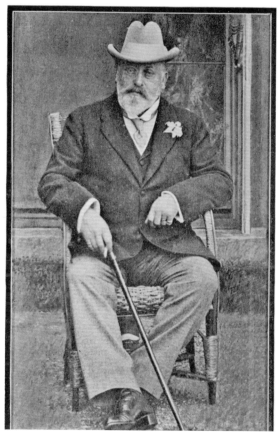

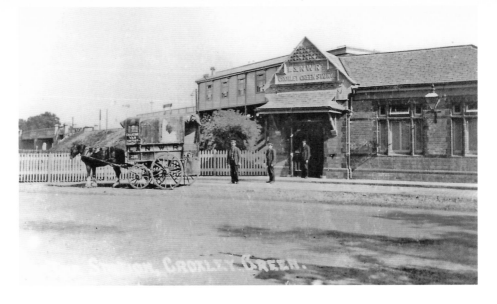

Croxley Green Station (1)

The station, operated by the London & North Western Railway (L&NWR), was opened on 15 June 1912 as part of the Croxley Green branch line, which ran from Croxley Green, situated near Cassio Wharf and opposite what is now a pub and restaurant, to Watford Junction via Watford West, and Watford High Street. An additional stop, Watford Stadium Halt, was opened on 4 December 1982 to accommodate visiting football fans. Note the horse-drawn railway delivery vehicle above, parked outside the station. On 10 March 1913, Croxley Green was put out of service for a short while when it was destroyed by fire, believed to have been started by suffragettes. The station was temporarily shut in 1996, together with the remainder of the line, but was eventually closed permanently in 2001. Today, the old line is being rejuvenated by the Croxley Rail Link, an engineering project that involves diverting the current Metropolitan branch away from its existing terminus in Cassiobury Park Avenue to use the existing trackbed between what was Croxley Green and Watford Junction, the proposed new terminus. The picture below shows the station in the 1960s.

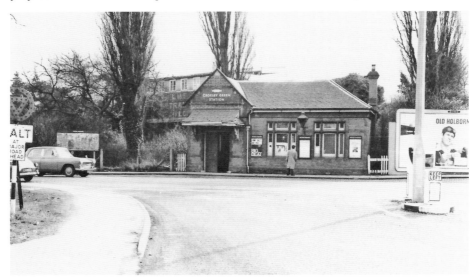

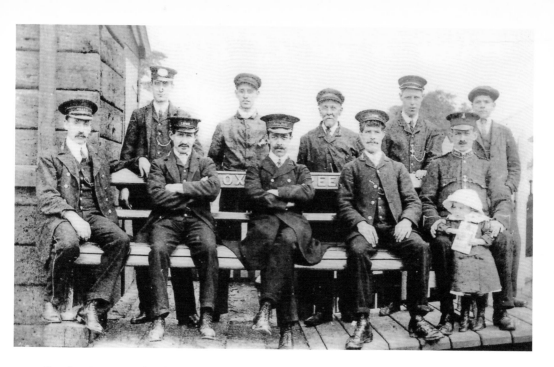

Croxley Green Station (2)

The stationmaster and his staff, plus a child, proudly posing for an early photograph. A three-car Oerlikon set is about to depart for Watford Junction in the 1950s image below. The trains were always called 'Oerlikons' after the name of the electrical equipment manufacturer. Others had Siemens equipment. They were always very comfortable to travel in, very smooth, warm in winter and cool in summer. One is preserved at York Railway Museum.

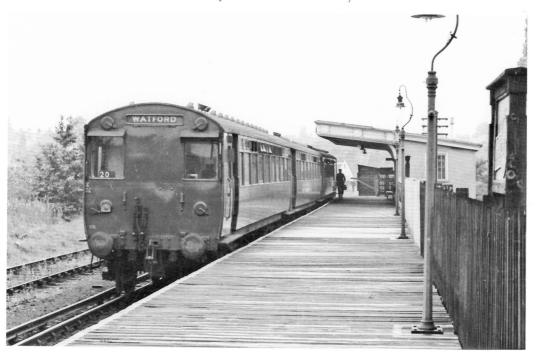

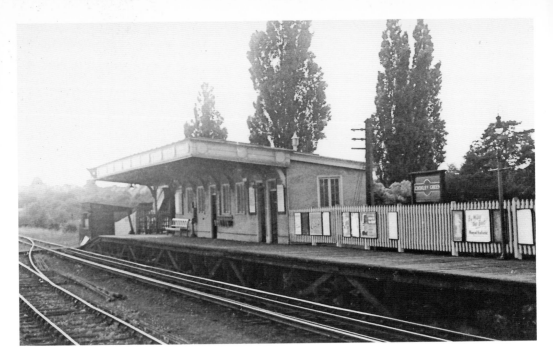

Croxley Green Station (3)

A view of the station taken on 23 June 1952, facing the end of the line and showing the electrification that had opened thirty years earlier on 30 October 1922. Only the platform line was electrified. The goods yard is just out of camera shot on the left. Below is all that is left of Croxley Green station today – the overgrown stairs that led to the platform.

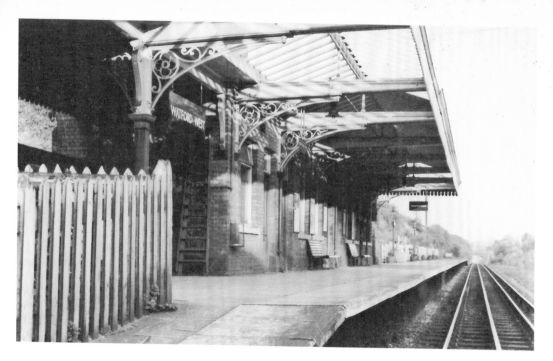

Watford West Station

Watford West Station in Tolpits Lane as it used to look, and as it appeared until recently (*below*). Only the concrete platform and the rusting tracks where once steam trains travelled remain, now overgrown with undergrowth and flora. The picture of the same view (*inset*), taken in March 2014, shows part of the clearance programme for the Croxley Rail Link. The trackbed was built wide enough for double track, which it will be in the future.

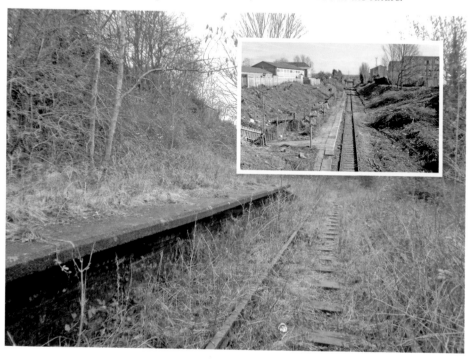

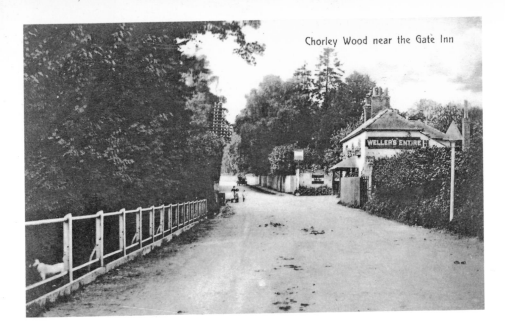

Chorley Wood near the Gate Inn

The Gate Public House, Chorleywood

Built in 1773, The Gate public house on the A404 Rickmansworth Road was a coaching inn offering ale and refreshments to the travelling public, who were levied a charge at the nearby junction of Dog Kennel Lane and Solesbridge Lane, where a tollgate was manned. Cattle on their way to the markets of Watford, Uxbridge and Rickmansworth could be watered at a nearby pond before the drover paid the levy. With the coming of the railway era, this was the beginning of the end for the turnpike trusts, which were at their peak in the 1830s; over 1,000 trusts administered around 30,000 miles of turnpike road in England and Wales, taking tolls at almost 8,000 tollgates. The Gate is now a popular country venue, offering a superb gastronomic dining experience.

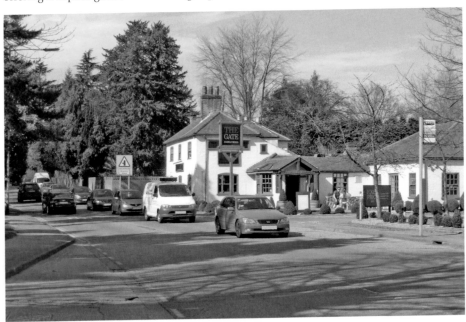

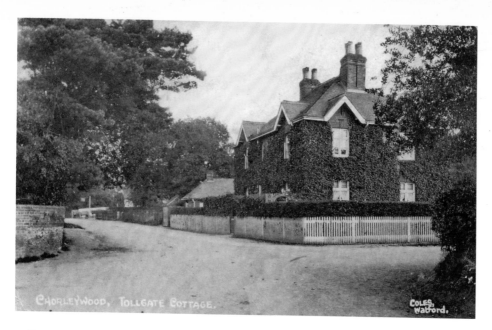

Tollgate House, Chorleywood

This rambling ivy-covered house, named after the tollgate that once operated on the site, was built on the corner of Dog Kennel Lane in 1897 for George Alexander, a renowned actor, theatre producer and manager in the late 1890s and early 1900s, who produced some of Oscar Wilde's plays, including *Lady Windermere's Fan*. While at Tollgate House, Alexander engaged the services of Sir Edwin Lutyens, a brilliant architect of the time who later created the Cenotaph in Whitehall, London, to design and build a new house nearby that was to be called Little Court. Enjoying 4 acres of land, the Tudor-style house was completed in 1912. George Alexander was knighted in 1911 for his services to the theatre and died in 1918, aged just fifty-nine.

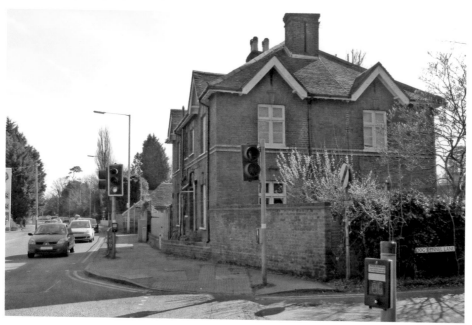

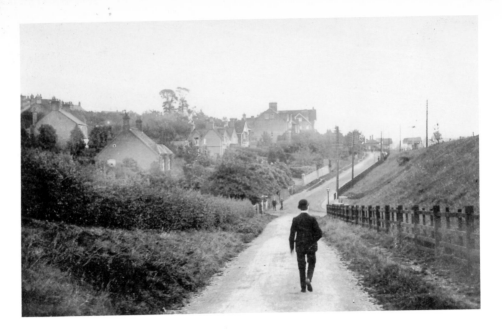

Station Approach, Chorleywood

A lone bowler-hatted commuter is seen walking to catch his early morning train from the Metropolitan railway station, just visible up the slope to the right of the picture. One hundred years later, and the vista is almost unrecognisable. Not only has the area matured with the growth of trees and vegetation, as one would expect, but the roadway where the photograph was taken all those years ago is now closed. However, the modern-day image is complemented by the appearance of the lovely old car, a cream 1929 Model 70B Willys Knight limousine, which drove into view just as the shot was taken.

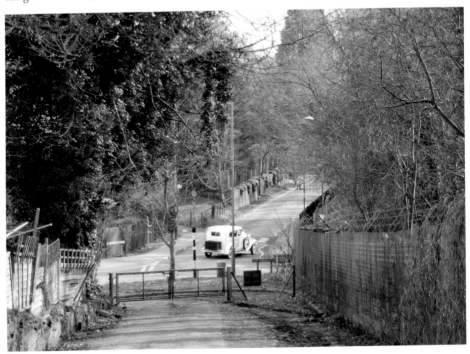

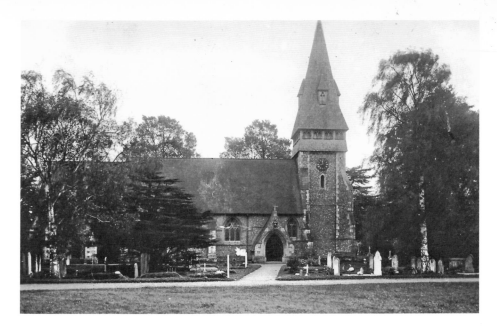

Christ Church, Chorleywood

This marvellous old snapshot shows Christ Church, situated opposite the cricket ground on Chorleywood Common. The original church was consecrated in 1845 by the Bishop of London, the minister being Revd W. Stephen Thompson. However, in 1870, in order to accommodate an increasing number of worshippers, the church was demolished and a new one built. The architect was George Street, who had designed the Law Courts in the Strand, London. Nothing remains of the old church now apart from the base of the tower, which supports the oak-clad spire. We see again the Willys Knight limousine, which was spotted driving up Station Approach, taking the bride to her wedding.

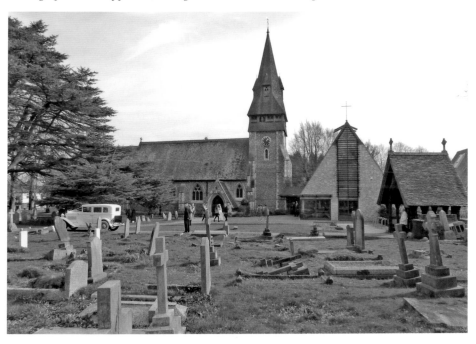

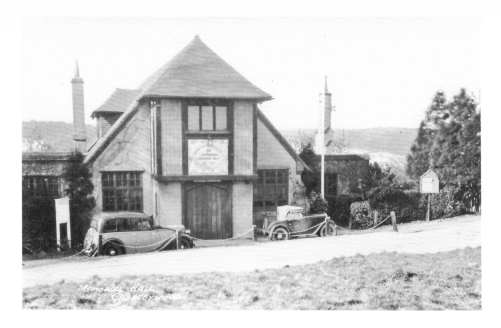

The Memorial Hall

As the First World War, 'the war to end all wars', drew to a close and the Armistice was signed in November 1918, communities such as Chorleywood had to face up to the appalling loss of life that had occurred and how best to preserve the memory of the fallen. The Memorial Hall, erected in 1922, was deemed a fitting and lasting tribute to the brave men who had lost their lives. Today, the hall, now one of the focal points in the life of Chorleywood, is used by several local clubs and societies, and is hired out for dances, sporting events and the popular antique fairs that are regularly held there, together with flower shows and many other activities.

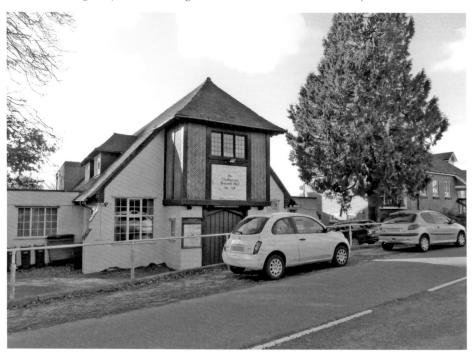

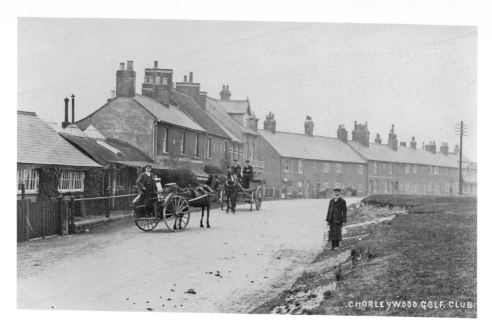

CHORLEYWOOD GOLF CLUB.

The Golf Club

Although the grazing of cattle on the beautiful 200-acre Chorleywood Common ended just after the First World War, the main recreational pursuits of cricket and golf have been followed on the common for much longer. The prestigious Chorleywood Golf Club, with its 9-hole course, was founded in 1890, and is the oldest club in Hertfordshire. The modern clubhouse offers comprehensive facilities and is an ideal venue for the many social activities that members and their guests can enjoy. In the early days, the clubhouse was a corrugated iron building called Rosie's Tea Rooms, which the club shared with the many visitors from London who travelled to the area when the railway was built. The tea rooms were used by the club until a new clubhouse was opened in March 1990.

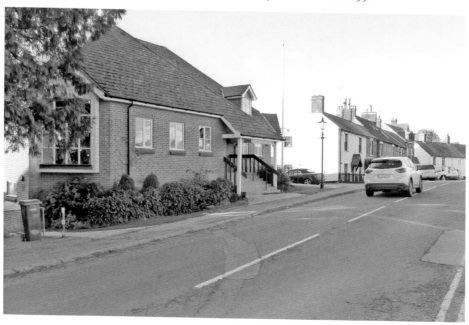

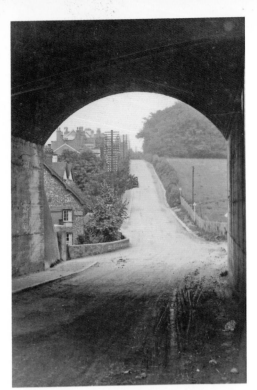

Shire Lane (1)

Two images of Shire Lane viewed from Station Approach through the Metropolitan railway bridge. At the time the picture on the left was taken, the local authority boundary line ran up the centre of Shire Lane, with Hertfordshire on the east side and Buckinghamshire on the west. In the late 1980s, Buckinghamshire wanted the boundary changed to the line of the M25, but as this would have meant that all of Chorleywood would have become part of Bucks. Hertfordshire County Council objected and submitted a proposition that the new boundary should bypass Chorleywood West completely to run along Green Street, meeting the A404 Amersham Road, which it follows up to nearly opposite St Clement Danes School, before snaking north-east towards Sarratt. Hertfordshire Council's proposal was accepted and implemented in the early 1990s. The photograph below shows the junction with Lower Road and Whitelands Avenue.

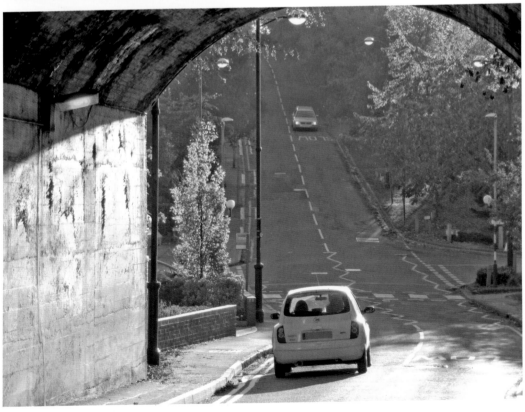

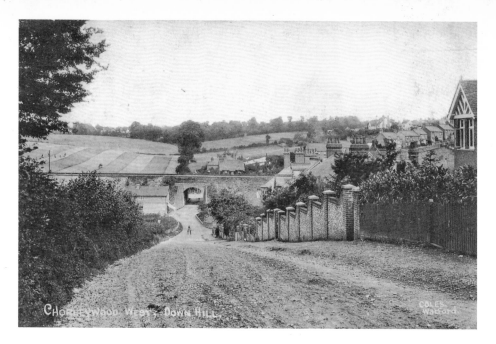

Shire Lane (2)

The early view above looks down the unmade surface of Shire Lane from the brow of the hill towards Tracey's Stores, in the shadow of the adjacent Metropolitan railway bridge. It is interesting to note that at this time there was no housing or shops on the Buckinghamshire side of the road in Chorleywood West, apart from Tracey's. The same outlook today was taken on a lovely autumnal afternoon in 2013.

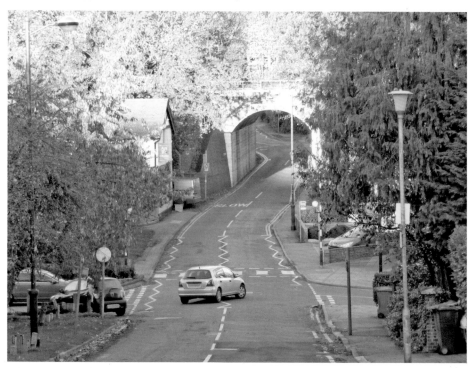

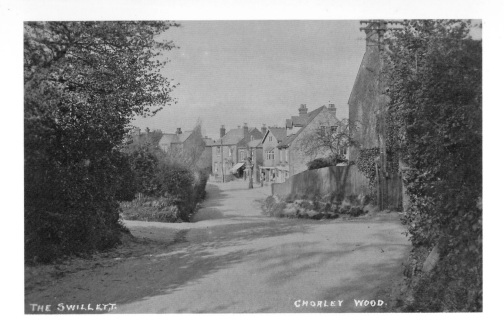

The Swillett

Travelling the short distance up Shire Lane and into Heronsgate Road, we arrive in the charming area known as the 'Swillett', a name that means 'a deep bowl within gravel that has never been known to run dry'. The above card, posted on 20 September 1927, shows Heronsgate Road at the junction with Bullsland Lane. Further along Heronsgate Road, where it becomes Long Lane, is to be found the unusually named public house, The Land of Liberty, Peace and Plenty. Originally a beer shop around 1830, it had become a pub by the early 1870s, obtaining its name from its close connections to the Chartist movement, who were prominent in the area during the 1840s.

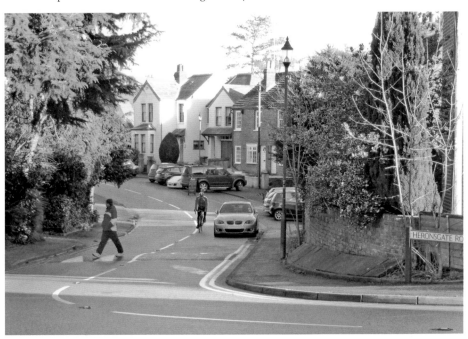

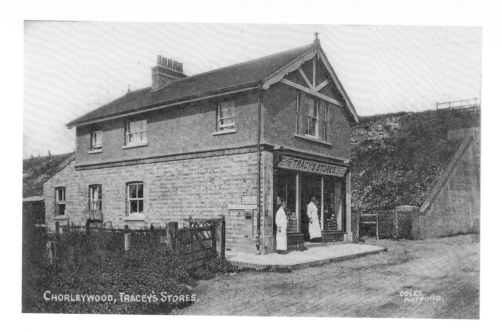

CHORLEYWOOD, TRACEY'S STORES.

Tracey's Stores

This old postcard of Tracey's Stores, one of the earliest shops in Chorleywood West, was sent on 3 October 1905, with the message reading, 'Dear Pal, How is this for Tracey's, not bad I'm sure? Delighted to know you are coming Sunday, will meet you on the Chalfont Road. Come early. Yours, Sunny Jim.' Tracy's at that time was also a post office and proudly proclaimed that a public telephone was available. Some of the staff are seen posing in front of the shop for the photographer. Comparing the two pictures, the building is still very much as it was over 100 years ago with Andrew Fleming, a high-class florist, now occupying the premises.

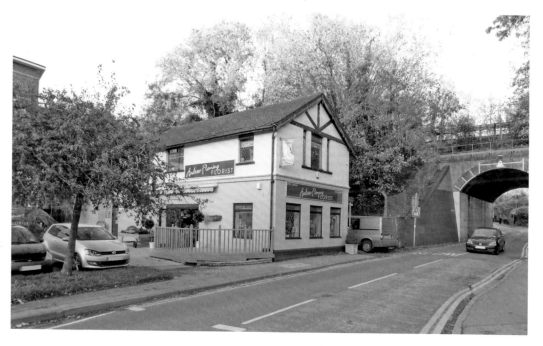

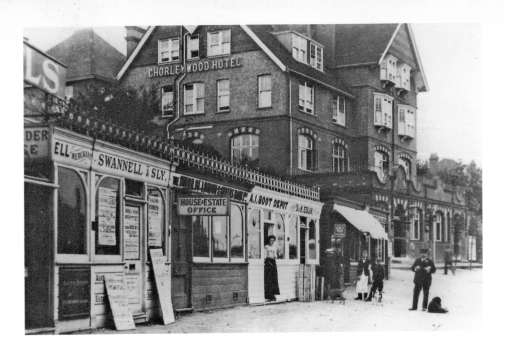

The Chorleywood Hotel

This superb turn-of-the-nineteenth-century snapshot shows the recently built (1890s) Chorleywood Hotel towering over a cluster of shops and businesses opposite Chorleywood station. The photograph clearly shows the house and estate premises of the well-known local firm of Swannell & Sly, the A. I. Boot Depot and S. & H. Edlin, to name but a few. With the passage of time, new buildings have replaced some of the old structures, almost blocking from view the hotel that was subsequently renamed The Sportsman, but which has now been converted into flats.

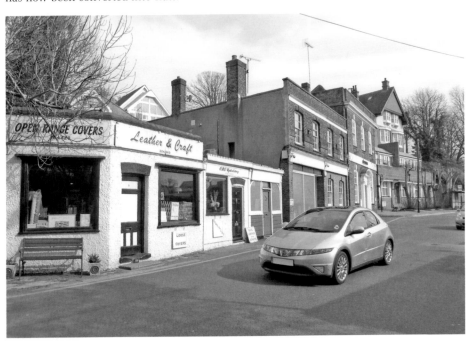

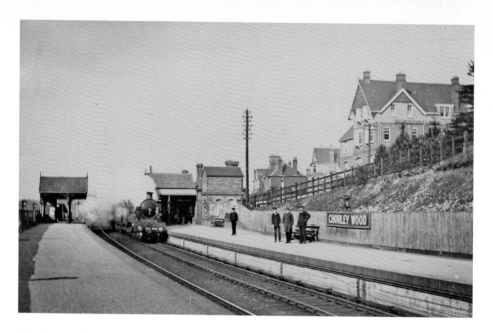

Chorleywood Station

Opening on 8 July 1889 as part of the Metropolitan railway line extension, 'Chorley Wood', as the station was initially called, has had several name changes over the years. It was renamed 'Chorley Wood & Chenies' in 1915, before reverting to its original name in 1934. The station changed to its present name thirty years later in 1964. Because electrification of the line in 1925 was only as far as Rickmansworth, this meant that Chorleywood was served by steam trains until 1961, when the electrification programme was completed and steam traction withdrawn. A warm autumn day in 2013, and a S8 Stock train is seen preparing to depart for the remainder of the journey to London. The prominent building on the right was once The Sportsman hotel, now closed.

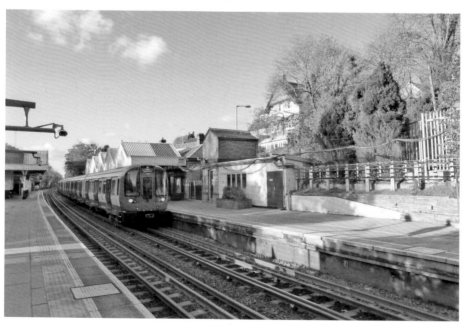

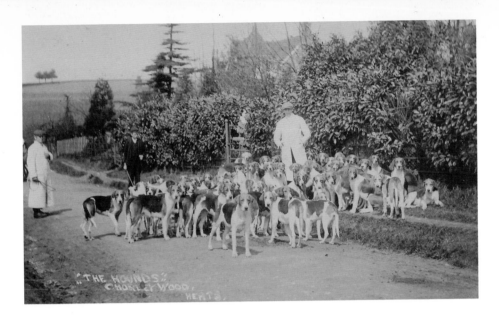

The Hounds, Chorleywood

These delightfully English rural scenes, captured during the early part of the twentieth century, show the hounds of the Old Berkeley Hunt above being exercised on Chorleywood Common near their kennels, where they would have been taken out each morning and evening. One of the favourite meets would have been held on Boxing Day morning. It must have been quite a sight to see the huntsmen, resplendent in their tawny coloured coats and white riding breeches, and the ladies looking elegant sitting side-saddle, setting off at the sound of the horn in the crisp, clear air, the baying hounds eager to pick up the scent of the fox. In 1970, the Old Berkeley Hunt amalgamated with the Herts and South Oxon Hunts to form the Vale of Aylesbury, which has since been merged with the Garth & South Berks, which in turn became the Kimblewick Hunt in 2011/12.

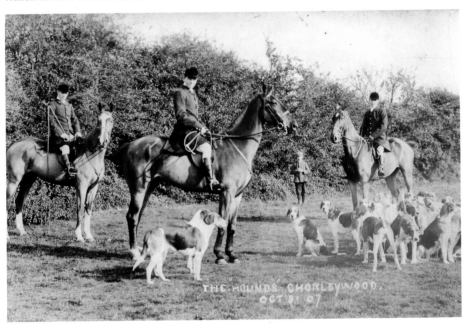

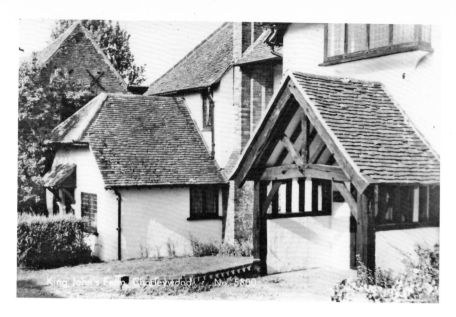

King John's Farm

At the junction of Shepherds, Stag and Berry Lanes in Chorleywood Bottom stands the magnificent old house known as King John's Farm. Dating back to the late Middle Ages, the farm, then called King's Farm, was the venue for the marriage on 4 April 1672 of Quaker William Penn to Gulielma Springett, daughter of Sir William Springett. The isolation of Chorleywood and the surrounding area was ideal for the Quaker movement to flourish unimpeded. As well as King's Farm, the Quakers, founded in 1652 by George Fox, also met at Meeting House Farm, as well as nearby Jordan's. Following several years living and preaching at Basing House in Rickmansworth (part of which is now the museum), Penn and his wife moved to America in 1681, where he founded the territory of Pennsylvania. William Penn died in 1718 and lies buried at the Friends' Meeting House at Jordan's near Beaconsfield.

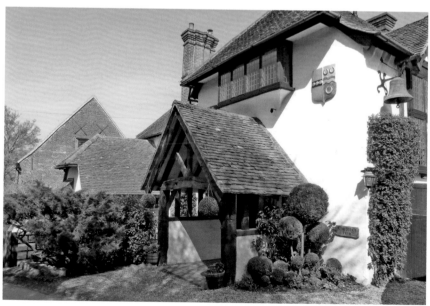

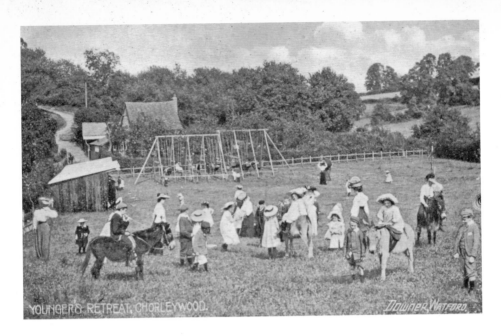

The Retreat

On the outskirts of Chorleywood in Chorleywood Bottom stands the charming Younger's Farm (The Retreat), which dates back to the pre-Tudor period. With the arrival of the railway, passengers at Chorleywood station, when enquiring as to the availability of refreshments in the area, were directed to The Retreat, now renamed Younger's Retreat, where the present occupant's grandmother would serve a welcome cup of tea and a slice of homemade cake. Younger's Retreat boasted a large field that attracted many visitors, especially children, who could enjoy the donkey rides and swings that were on offer. During the 1990s, Olive Entwistle, the owner of Younger's Retreat, sold some of her land, including the field, where flats for elderly people now occupy the site, and where the laughter of young children at play echoed all those years ago.

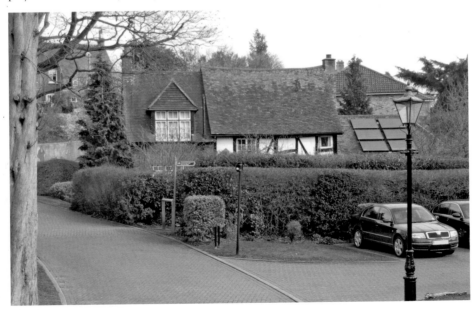

Bought of J. W. Darvell,

WHOLESALE & RETAIL
COAL AND COKE MERCHANT,

TERMS
NET CASH
ONE MONTH.

Head Office: Chorleywood.

Also at
CHALFONT ROAD,
STATION
AMERSHAM COMMON
BUCKS.

Herts, *Jun* 1929

Mrs King
Dolts Hill Sarratt

1928

May 4	1 Ton Best Nuts a		4/3	£2 3 0	

With Compliments

J. W. DARVELL,
CHORLEYWOOD.

No. 1929 *Dec 6* 192 9
Received *Cheque*
Value £ 21 3 0

Per *H Phillips*
With Thanks.

J. W. Darvell
A 1929 receipted bill from J. W. Darvell (coal and coke merchant) for the supply of goods
to Mrs King of Sarratt.

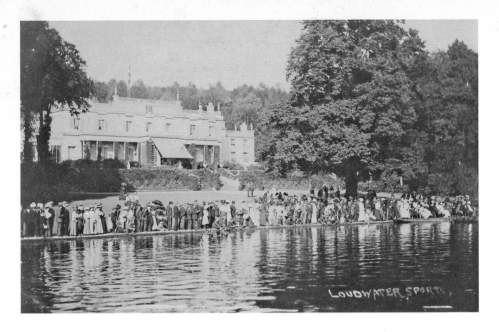

Loudwater House

Built around 1810 by French prisoners of the Napoleonic Wars, the impressive mansion of Loudwater House was bought by Joseph Arden from the Hayward Estate following the death of its previous owner, James Hayward, in 1848. One of the most flamboyant characters to live at Loudwater House was Scottish aristocrat Harry Panmure Gordon, whose pride and joy was the lake that he had dug out complete with an island. Gordon died in 1902. During the early 1900s, the lake attracted large crowds, where extremely popular swimming events and other water activities were organised. In 1924, the estate was purchased by Cameron Jeffs, a property developer, who converted the house into twelve flats. As well as this accommodation, Little Wing, at one end of the house, was also converted from what was once the chapel.

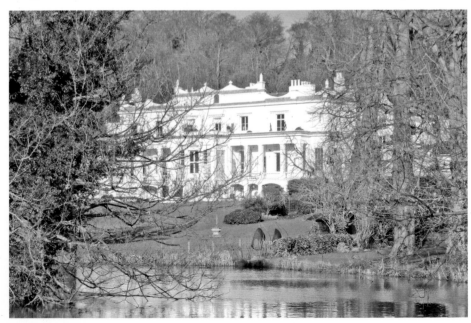